techniques
OF DRAWING

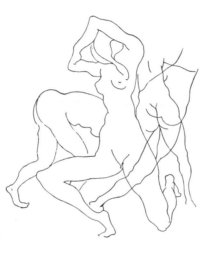

BY
HOWARD SIMON

Dover Publications, Inc.
New York

TABLE OF CONTENTS

Published in Canada by General Publishing Company, Ltd., 30 Lesmill Road, Don Mills, Toronto, Ontario.

Published in the United Kingdom by Constable and Company, Ltd., 10 Orange Street, London WC 2.

This Dover edition, first published in 1972, is an unabridged and unaltered republication of the work originally published in 1953 by Sterling Publishing Company, Inc., under the title *Primer of Drawing for Adults*. It is reprinted by special arrangement with Sterling Publishing Company, Inc., 419 Park Avenue South, New York City 10016.

International Standard Book Number: 0-486-21578-4
Library of Congress Catalog Card Number: 72-87523

Manufactured in the United States of America
Dover Publications, Inc.
180 Varick Street
New York, N. Y. 10014

I. DRAWING IS EXPRESSION

Drawing has for so long been closely and naturally related to man's desire to express himself that the linear pattern of his thoughts and emotions can be traced back at least 17,000 years.

Drawings, made with a sharp tool on the stone walls of the Altamira caves in Spain, expressed aspects of life in that age. Since then man has constantly recorded his impressions of his surroundings on the bark of trees, in stone, and at last upon paper. Today the machine push-button civilization has not yet succeeded in robbing man of his natural impulse to draw.

Among adult students who have only evenings to give to learning to draw, it often seems that the more complicated and mechanical his daily task, the more eagerly the individual turns toward the graphic medium for expression.

Over the years, the technical means of drawing have changed little although man himself has changed much. Today, as five hundred years ago, a lead point, brush and ink, or pen on paper are enough to stock the graphic artist with the very tools used by the greatest figures in the history of art.

For many years the beginning artist was taught to copy drawings until by constant practice he could imitate the outward characteristics of another's line and technique. There followed a long apprenticeship in drawing from the cast (plaster casts of classic statuary) and, finally, students were allowed to draw from the live model. The ability to copy nature was in this way developed. But this old form of learning excluded any expression of the personality or individuality.

To learn to draw you must learn to see. All of us have experienced an inability to remember even approximately the shape of familiar objects. The essential shapes of things seem always to elude us. How to remember and how to set down these shapes in line and in form are learned by training the eye and hand. To see things as they are and not as you imagine or remember them requires a little unlearning and more learning, but this is basic and essential.

Cézanne said that if you can draw the cylinder, sphere, and cube you can draw anything. At first sight this seems like a formula for reproducing the seen shapes of things. But Cézanne also said, "I am always trying to *realize*." Cézanne meant by this that to *understand* the form of things and to give dimension in space to these forms were his intentions. Only then can the reality of the form be felt even though the transcript from nature may not be exact. *The character and quality of a form are important rather than the superficial appearance.*

We should understand this and make use of it not as a formula but as a means to the desired end. In this case the end is the simplification of form to enable us to

carry expression of the seen into whatever medium we are using.

To learn to draw you must learn to feel. The tactile or *"felt"* approach to drawing is not new.

We must recognize at once that drawing is an abstract device. The most naturalistic of drawings is still in no sense a copy from nature. In drawing we are constantly transferring into symbols the object seen and remembered. *There is no line in nature.* When we *feel* the shape of an object we know that it is three-dimensional, and only by translation into terms of linear edge and by systems of light and dark values can we convey the feeling of form to paper.

In the language of *Drawing and Painting,* Arthur Pope speaks of this translation in terms of linear edge as " . . . marking the connection and disconnection of planes forward and back."

The simplified and the non-realistic character of drawing is well conveyed by even a casual study of landscape drawing.

No attempt is ever made to describe in detail the multitudinous leaves seen on a tree or the ridges and depressions of the bark, or all the fissures in a rock.

Instead, a kind of synthesis takes place. The non-essential forms and shapes are simplified and emphasis is placed upon the relation of these forms in space.

Today more people are interested in learning to draw than even a few years ago. The renascence of interest in learning to draw proves among other things that the impulse and desire to draw cannot and should not be suppressed by our mechanized and so-called atom-age civilization. It is perhaps deeply significant that this is so. Indicative of this aspect of drawing is the fact that the terms of psychopathology often are used in connection with art and art criticism today. Drawing itself, for example, is often referred to as therapy.

In *Techniques of Drawing* my aim is to return to positive values and direct expression uncomplicated by any other

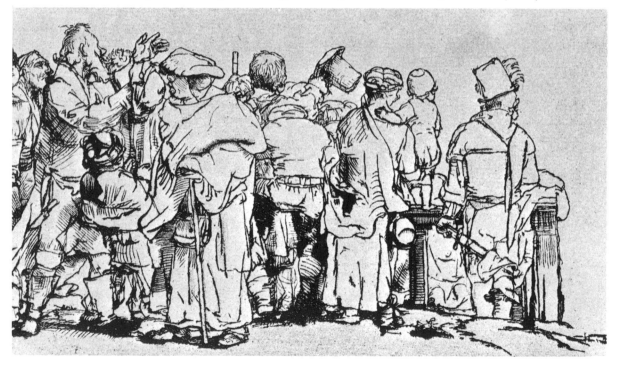

Detail from "Christ Shown to the People" **REMBRANDT**
(*Full drawing on page* 41)

12

consideration than the natural statement of line and form.

This book is intended as a new primer of instruction for those students who want to learn to draw for pleasure and self-expression.

In the course of many years of teaching adults who seriously desire to learn to express themselves in line, I have developed *Techniques of Drawing*. It is a natural outgrowth of experience and observation, experimentation and work with sincere students of art. Their questions and daily problems and needs have helped to formulate a guide for others, as well, who come to art expression with hopeful and enthusiastic energy.

You can learn to draw only by drawing. Drawing based on an instinctive feeling for expression can be pleasurable and rewarding. If you want to express yourself through drawing you can learn, but (as all else which is rewarding) learning to draw requires time and devotion.

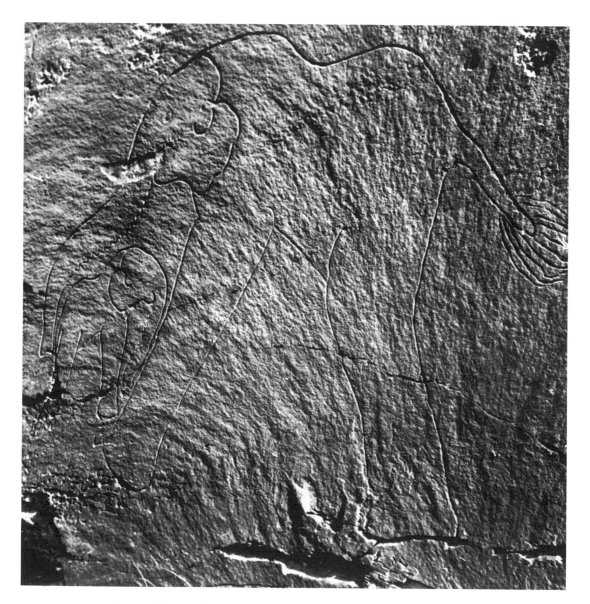

Incised by prehistoric man on stone near Ain Safsafi, Africa

2. HOW TO BEGIN TO DRAW

Conte chalk

Sable brush

Dropper *Fountain pen*

Sharpened stick

THE MATERIALS

The materials to be used in learning to draw are few but important. A master can find charm and expression in a sharpened stick dipped in ink. Rembrandt drew with a crow quill pen and watered ink. The years have only added a warm brownish cast to these drawings. Commonly in use in the Renaissance was the sensitive line of the silver point not unlike our hard pencil of today. Also in use then were red and black chalk. Much earlier, men scratched wonderful decorations on bone with a sharpened point. Incised on the stone walls of caves flowing lines represented animals in movement.

The technical means of expression have changed so little that a list of materials and tools in use today still include most of the earliest ones.

Newer among our tools is the fountain pen which is an excellent instrument to record movement and impression. Almost any fountain pen will do, but the most practical for drawing is specifically made for this purpose. It contains no sac but is filled directly with an eye-dropper and uses Indian drawing ink. Do not try to put Indian drawing ink in an ordinary writing pen. It only clogs it and rots out the sac.

A handy useful tool is the #4 sable watercolour brush. This varies in quality. Be sure it is made of *sable*, although it may cost more than one offered as a sub-

stitute for sable. Before purchasing, dip the brush in water. It should come to a perfect point. Try it on paper. Then press it lightly against your finger. If it is a good brush it will bend and snap back at once to its original point.

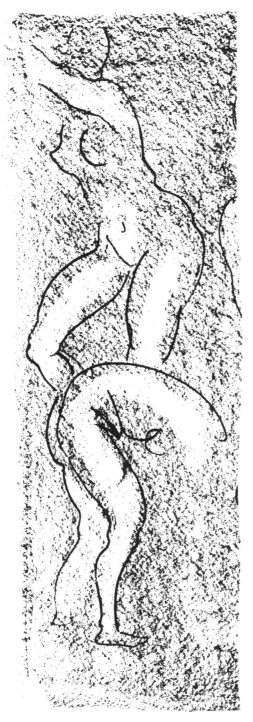

Sharpened stick, ink and Conte chalk

FROM TOOLS TO TECHNIQUE

For the beginner it is a good plan to let the tools help dictate the technique. Although much has been written about technique and style in drawing, both refer to the same thing: the *how* of drawing. Technically a drawing is superb when it expresses by the simplest means the ideas and feeling of the artist.

A perfect drawing would be one in which no line could be left out, no flow or pressure of the pencil changed.

When you come to choose the tool for a particular kind of drawing, think first of whether you would draw in line or in values of light and dark. In the first case the point such as that of a pencil or pen will give you the clue to the style. In the second, the broad base of the chalk or brush should help you towards the simplification of the mass element in the drawing.

Do not be misled by the dexterity with which you handle a pencil. This ease, born of long acquaintance in script writing, may betray you into trying tight, rigid, over-detailed drawings.

Take a 2 B lead pencil sharpened to a longish point and try one of the exercises outlined in "The Linear Edge" chapter. Now try the same exercise with Conte chalk #3, either black or red, and you will find that in the first, your instrument and the sharp point will lead you to a small drawing on smooth paper, while the chalk, because of the broad dull point will suggest large paper and a bolder freer approach.

It is from these different tools that an approach to technique is found. How best to use them is personal. Once the willingness to give in somewhat to the tool is understood, one is least hampered by the newness of the material.

PAPER

Paper affects the style and technique of the drawing. A smooth hard paper is good for pen and pencil alike when used for line drawing. Charcoal requires a special paper that is grained, and always sold as Charcoal Paper. Some of it is ribbed or lined. This is called "laid" by the manufacturers and some of it is irregularly impressed to give a tone undisturbed by lines. You should try both and choose the kind that suits you best. They are equally easy to use.

In using the Conte chalk in the beginning you will find the newsprint pad inexpensive and sympathetic to the chalks. Because of its inexpensiveness it is less inhibiting to use. There is a certain freedom that one feels when using inexpensive materials. Experiment and familiarize yourself with these for the sheer practice of material uses. It will lead you to make free drawings.

YOUR STUDIO

Fitting up a studio corner in your home is a problem not too difficult for most to solve. If you have a room in which to work, choose for yourself an easel at which you can either stand or sit while at work, or a drawing board which you can lean against a table or desk.

Keep nothing on the table but the drawing itself. Find a small portable table or tabouret to hold the materials, a large portfolio in which to keep papers and finished drawings. A small narrow chest will do to hold materials not in use. Keep the actual drawing space free if possible.

Good light is essential but don't make a fetish of north light. If you have it, of course, it will be steadier and you may increase your working time a little. But good drawings can be made with southern, western, or eastern light, too. Let the light come in from the left side so no shadow from your hand will fall on your work as it progresses. For night light a good artificial lighting arrangement must be made, preferably using a double fluorescent lighting fixture with mixed bulbs, blue and daylight.

If the daylight is too direct and strong, screen the lower part of the window with a translucent cloth so that the glare is cut, but the light still enters. If you are seated, don't crowd your chair to the desk but allow your arm plenty of free movement. Most drawing tables can be adjusted so that the angle is a little more acute than in writing. This enables you to see your work while in progress. Keep the small table with your materials to the right as you work and try to anticipate all of your tools for the drawing you plan.

Keep your brushes and pencils upright in a container with a broad enough base so it is not easily upset. They should be close at hand when you need them.

EASEL VS. TABLE

When drawing from life the easel is better than the table. The simplest form in general use at the art schools looks like this:

Drawing boards are made either of plywood or wood joined in such a manner that warping is not possible even though the board may be used with dampened paper as in the stretching method.

Masking tape is an adhesive used to attach the paper to the drawing board. It comes in convenient rolls less than an inch in width and it has the strength and stickiness to hold watercolour paper during stretching, after dampening.

If you use a table instead of an easel, place your drawing board on the table edge and rest it on your knees. This approximates the easel position and is good because as you work you see both the model and your work without too much shifting of head and eyes. Another and still more important aspect of the working position is that distortion caused by perspective occurs when you lay down your drawing. As things or objects retreat they grow smaller. This same principle applies to the parts of your own drawing while you are making it. Keep your drawing at an angle.

CHALK

The Conte chalks have the advantage of being square and so will give a broad stroke quickly and with variety and density according to pressure. Try it with slightly greater pressure at the top of the crayon and you will find that a gradation of dark to light is achieved with one stroke. Try the point at one corner of the squared edge of the chalk and you will find a line as thin as you need. This is an excellent material for the early stages of learning to draw. Even its disadvantage—that of being difficult to erase—is questionable since these early drawings should not be changed by erasure anyway.

CHARCOAL

It is difficult to conceive of a course in drawing that will not require charcoal. Yet because it is easy to make changes once a drawing is made in charcoal, it is also therefore hard to keep your drawing without the bother of applying fixative. It is even difficult to keep it from smudging and rubbing off during the time it takes to make the drawing. The hand must be kept free of the drawing.

There are several grades of charcoal. I suggest *vine* charcoal which makes a beautiful black, and is regular in shape, round and easily pointed on a sandpaper pad. One must be careful not to press too hard on the vine charcoal since it is easy to break. This difficulty in handling is more than made up by its softness and regular quality. Some charcoals, particularly the harder grades, are irregular in their blacks and difficult to use.

You cannot use charcoal on very smooth papers such as newsprint since there is no tooth or fissure to hold the particles.

WATERCOLOUR

You ought also to acquire two tubes of watercolour—one Chinese white and the other lamp black with which to make variants of grey.

A tin mixing tray to prepare the values of grey that may be mixed from black and Chinese white is necessary. Also a glass jar for water is needed.

OIL COLOURS

For the longer studies from the model in which I suggest the use of both oil and tempera on large scale, the following materials will be needed:

Oil colours: Titanium white
 Burnt sienna
 Ivory black
 Viridian green

These colours should be purchased in studio-size tubes, with the exception of the white which is more practical to buy in half-pound tubes.

Thick cardboard which is readily obtainable at art shops in large sizes is a good experimental material on which to paint. It must be coated with shellac before use since otherwise it is extremely absorbent and therefore difficult to paint on. Be sure that the shellac is completely dry before working. An even better material is *masonite* which can be sawed to size and then coated with two coats of flat white on its smooth surface. When dry the flat white is an excellent and permanent ground on which to work.

25 x 30 or 30 x 40 are good sizes for

these large beginning experiments in form drawing with oils.

It will be necessary to have some kind of palette on which to mix the various colours with white. I suggest a disposable paper palette since this is a time-saver, particularly in the classroom where clean-up time is a problem. Disposable paper palettes come in the same sizes as wooden palettes. They are made of waxed or oiled paper. The oil in the paint is not absorbed more than by wood. At the end of the day's work, one can peel off the top sheet and leave a clean palette to start fresh.

Rectified spirits of turpentine are used for thinning the colour so that the brush may move freely over the surface and drawing not be impeded by thickness or dryness. For drawing in oil, the following brushes may be used: one #3 round oil bristle, two #4 flat hog bristles, two #6 flat hog bristles; also a palette cup to hold turpentine, a palette knife for removing paint or scraping on the drawing itself.

The bristle brushes are in general use for painting in oil and I specify the *flats* because they have longer bristles, and hold more paint. They last longer, besides. The shorter, or *bright* type wear down quickly on a rough surface and in time are unsuitable for drawing.

DRAWING PENS

Almost any steel pen may be used for drawing, but special pens are made for this purpose. Any art shop will recommend good pens for use with Indian ink.

At first one ought to try a medium fine point. As you progress you will develop preferences. If you like an accented line, one that has varying degrees of thickness, you probably will like a very fine

point. If you like an unaccented line—one of equal thickness throughout—a stiffer pen is called for.

The following numbers are a guide: #404 medium, #303 fine, and #170 very fine.

All of these pens are at their best when used on a smooth surface. Bristol board is especially made for pen use. I have found from my own experience that a good quality bond (20 lb.) is equally good for pen drawing, made with either of the drawing pens above, or the fountain pen.

Bristle oil brushes

19

INKS

For use in an ordinary fountain pen, jet black of any manufacture may be used. In the drawing fountain pen, Indian inks are suitable. These are waterproof and allow for washes on top of the drawing.

LIST OF MATERIALS:

1. Conte chalk #3 black, red
2. Charcoal, vine
3. Pencil, drawing #1 H, 2 B, 4 B
4. Wood matchstick, sharpened to a point
5. Inks: Indian, jet black writing, brown drawing
6. Easel
7. Table
8. Drawing board
9. Fluorescent light for desk or table, preferably should have floor stand base
10. Sandpaper pad for sharpening charcoal and pencils
11. Paper: newsprint pad 18 x 24, bond paper 8½ x 11, watercolour paper, bristol board, charcoal paper
12. Masonite board, butcher board.
13. Brushes: one water-colour red sable #3, one each oil brushes: #3, #6, #12 flat hog bristle, #3 round
14. Turpentine, rectified spirits
15. Fixative for charcoal
16. Blower for fixative
17. Pens: drawing pens #404 medium, #303 fine, #170 very fine, special fountain pen
18. Penwiper
19. Oil colours: white titanium, burnt sienna, viridian, ivory black
20. Shellac for coating thick cardboard
21. Flat white paint for masonite surfacing
22. Watercolours: Chinese white, ivory black (warm), lamp black (cold)
23. Tin or china mixing tray for watercolour
24. Jar or glass for water
25. Masking tape
26. Drawing pins (thumbtacks)
27. Kneaded eraser.

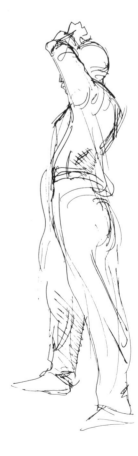

3. THE LINEAR EDGE

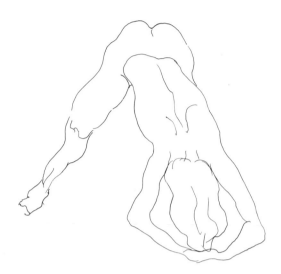

Before the artist begins to draw he has already made a great many far-reaching assumptions. For instance, he has assumed that a line, black on white, or the reverse, can give the complicated impression and suggestion of the shape of an object, figure (animal or human), tree, or flower. And, even further, that arrangement, direction, and values of light and dark can produce certain emotions in the observer as well as in himself. In a sense he has created a language and is making use of it therefore as a means of communication. This is, of course, what drawing is.

It is obvious, after a few moments' thought, that no *line* exists at all. A person may with pencil or charcoal explore a shape as it appears to him against a background. He assumes in that case the existence of a line.

At best there is only the *shape* of the object as seen against its background. This can perhaps be illustrated by a line that follows the shadow cast by an object, an example used by Leonardo da Vinci in his *Notebook*. It was Leonardo's belief that this drawing of a line around a shadow represents the very beginning of human expression in the drawing medium.

From drawing the outline of a shape it is a step to the next stage: a more complicated, more sophisticated understanding of objects, forms and figures as they stand or move in space. Translated into drawing, the line that describes the form is what I term *the linear edge*.

It is assumed that the person at work with his drawing paper before him knows that no figure is flat. A child draws a head by making a circle on his paper.

And to the child the symbol of the circle is satisfactory.

There is no flatness in nature. Everything has a third dimension. The linear edge must express this dimension. The line you draw to express dimension in space must travel around the form. This means the line in your drawing travels not in one direction alone. The line of your drawing must travel down and around, in and out of the figure.

We must analyze what is meant by *placing objects in space*. To do this we choose three objects or forms having three dimensions. For example, a bottle, a grapefruit, and a glass. We arrange them. Now, if we look at the arrangement from the top which is known as a plan view, it will look like this:

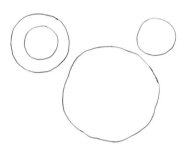

If we look at it directly at eye level, it will look like this, or nearly so:

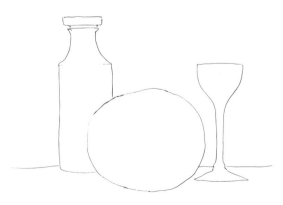

And if we look at it from above, which is the most natural way to see it, it will look like this:

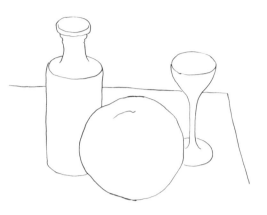

The last drawing shows more clearly the space occupied by the objects in relation to each other. It reminds us, too, that in oriental art (Japanese and Chinese, in particular), the natural look of an object in space is disregarded, and a convention set up in which the objects close to us are drawn low in the picture plane while those more distant are drawn higher, but the size of the objects do not necessarily diminish in the distance as in naturalistic perspective.

One method is not better than the other, but it is different in concept, and this should be understood at once. Often we choose to make our pictures as though we were looking through a window on a scene, with the foreground objects large, detailed and important, and those farther from the eye less detailed and smaller. The illusion consequently is developed of objects seen in space. In skilful hands there is built up, by these means, a feeling of actuality.

Placing objects in space (perspective) is not our only problem. It is also necessary to place the lines that show the form in such a way that a harmonious arrangement of the subjects occupies the whole paper.

22

This introduces the subject of pictorial composition, or the making of pictures. It is only touched upon here and taken up in greater detail later on in the book. Its place here is necessary because one should think in terms of *picture* from the very beginning. If whenever you draw you make some effort to use the whole paper as already described here, you are on your way to picture making, and the whole direction of your studies will take on meaning.

In the classroom the beginning student often asks, "Where do I begin my drawing?" You can start anywhere, but if some long line occurs near the top of the drawing, that is a particularly good place to begin. After one line is established in direction and length, the others may be related to it.

There is a certain purity in line drawing, a finality of statement that is challenging. In drawing, the purpose is *to make a picture*. Making a picture means making the best use of the paper.

Use the paper itself as part of the picture. As an example, if you make use of a few lines you will find you can place them either to make a design (or picture) or set them down in such unrelated statement that no picture exists. Lines may be used to express a rhythmic design, one of stable structure, and obvious movement. Or else you can place them so they mean nothing.

You will think the simple line around the linear edge merely an exercise, as indeed it is, in the beginning. But some of the subtlest and most sophisticated of drawings are made in just this manner. Excitement and pleasure of discovery are in the study of a masterpiece of line such as may be found among the grouped figure drawings of Picasso, one of which is reproduced on the next page.

See how justly and with what lack of apparent effort the line bounds the forms and how unmistakably the figures take their place in space.

The possibilities of line are enormous. Its use is as old as art. Let no one underestimate and let no one feel its possibilities have been plumbed to their depth. Every generation will bring out new experiments in line in the search for creative expression.

Some beautiful examples of pure line drawing are to be found in a book printed in the fifteenth century by Aldus of Mantua, one of the greatest of printers and scholars in Italy. These drawings, an example of which is reproduced on page 25, have been variously attributed to Botticelli, Raphael, and to other masters who lived during the period of its printing. Search these drawings for the simplicity in design that goes almost to the point of severity.

TACTILE VALUES

The sense of touch—the so-called tactile value, often spoken of in contemporary art criticism—is best described, in the drawing sense, as the exact coordination of eye and hand sensitive to the touch. It is as though one were to pass the fingers over a form to search and examine it, learn its weight, depressions, and protuberances. All forms present a linear edge, but sometimes it is subtle, sometimes difficult to find. It is the search for and the realization of the linear edge that lend character and quality to drawing.

There is no easy way to enable one to set up a formula that can be followed by all. You must learn what is meant by the overlapping of planes in the figure, for instance, and how to express them in

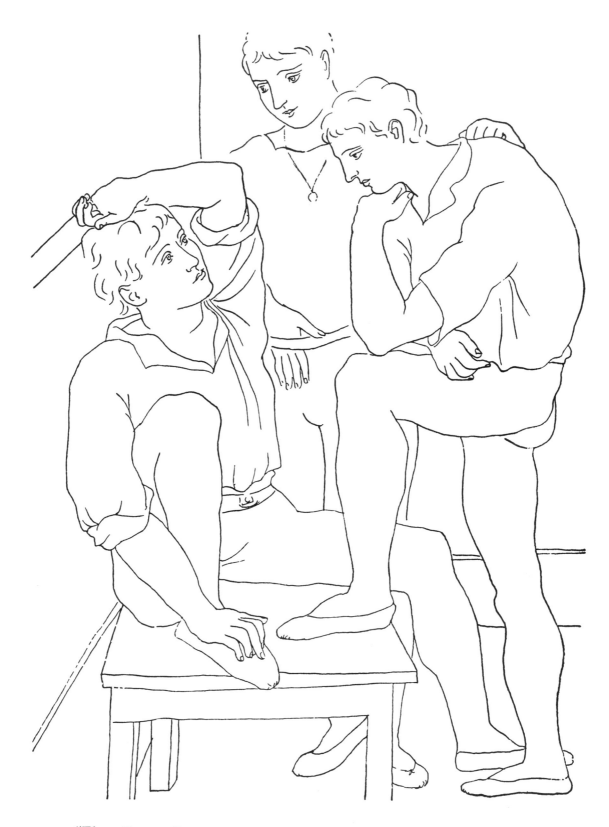

"Three Dancers" PICASSO

 This is a splendid example of the arrangement of figures in space. A
rhythmic line encloses the form, giving substance to it by means of in and out
lines, as described on page 22.

24

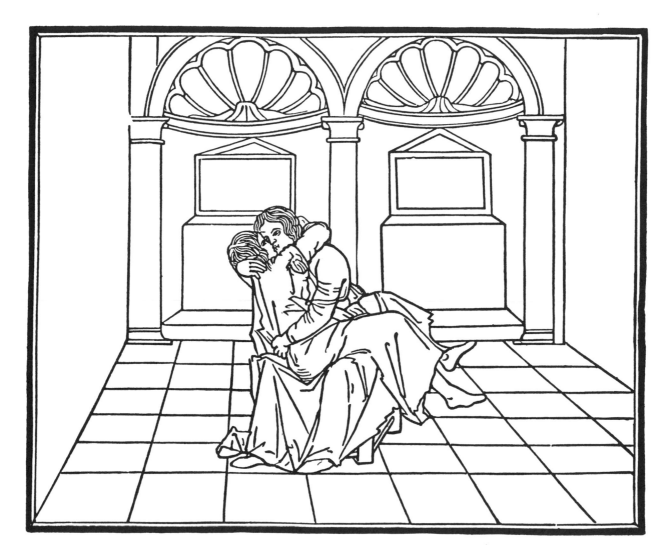

Illustration from the "Dream of Poliphilius" Artist Unknown
The drawings in this extraordinary book printed by Aldus in Italy at the height of the Renaissance have been attributed to many of the masters of the period, Botticelli among them. The function of the linear edge is well illustrated by this woodcut drawing.

line. Use your sketch book often, put down in it the overlapping forms that are easy to feel and distinguish, until the more subtle ones begin to make themselves known to you.

Quality in drawing is the result of the never-ending search for the essential and the rigid elimination of all that is non-essential, tricky, or mannerism.

LINE TEMPO

Tempo has much more to do with quality in drawing than is at first apparent. A line drawn quickly has one character, and one drawn slowly another character. This should provide a basis for study. The technical equipment of the artist should include the knowledge of when to use a rapid line and to what purpose. Many artists use the same kind of stroke made at the same speed or nearly so in all their drawings. A kind of uninteresting, even deadly similarity creeps in as a consequence. Appreciation of this timing element is found in the drawings of Toulouse-Lautrec, Rodin, Daumier and Tintoretto among others.

The early exercises in this book are intended to be done in slow tempo line. Keep to this practice. Learn to see while you are drawing.

Often the student draws so quickly that form comprehension is almost impossible. Slow down. Search for shape. Try to feel roundness. Try to feel fullness of the form as you draw. Because of overemphasis on seeing and feeling, distortion occurs. Don't let this discourage you for it may well be a positive virtue. All expressive drawing contains a certain amount of distortion.

In the desire to render tactile values (sense of form through touch as well as sight) in a line convention, distortion becomes a tool in the hand of an artist, but let it come naturally to express the mood and design.

The great drawings are rarely exact in proportion. Michelangelo exaggerated. El Greco distorted to make clear his meaning, bringing his work out of reality and towards an expressive movement and mood. The effect is to make his elongated figures appear touched with a kind of magic of the spirit. We do not consider that this reliance upon the feeling of form belongs to the sculptor alone.

Rhythm is expressed by repetition in the flowing line which in turn represents movement. Rhythm must be felt by the artist. Let your arm swing free as you draw. Hold your pencil or crayon lightly. Do not pinch it. Swing the long lines. Do not cramp your style because of fear of an incorrect line.

Action moves around a core. The line bends and twists, following the long lines of movement. Try to synthesize the moving lines. Be careless of their number. Keep your mind on the action itself. You should feel the pull of your own shoulder, the bend of your limbs as you draw. In Daumier's drawing, "Un Type" (see page 58) you will find an example of this kind of drawing; the swirling moving lines are synthesized to *say* movement. At the same time the form is captured not by a single line around the edge of the form, but by many lines. Some of them perform no function and define no forms but simply give the feeling of movement.

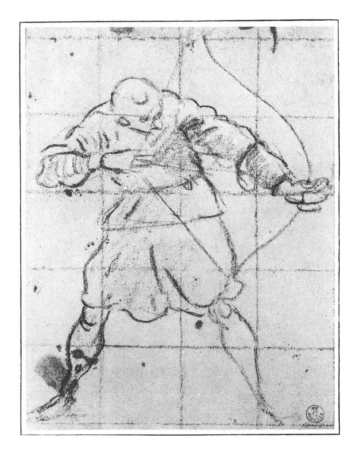

Study for an Archer **TINTORETTO**
*This drawing represents the utmost in simplification and at the same
time is alive with movement and design quality.*

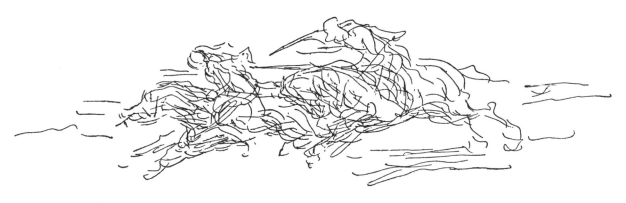

Horsemen **DAUMIER**
*Daumier's masterful drawing makes its movement felt through the haze
of seemingly unnecessary lines.*

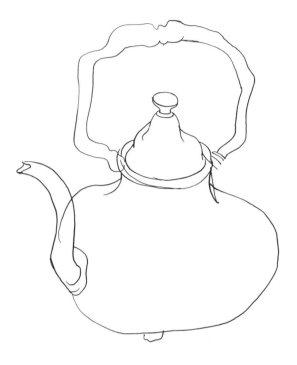

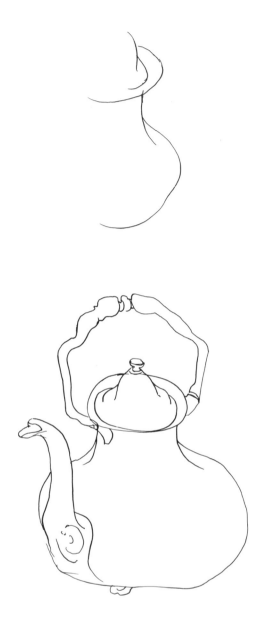

PROBLEM I

Set up an object as a still life: a teapot, for example. Place it about three feet away on a table top and against a background that will clearly reveal its shape.

With a sharpened 4 B pencil on an 18 x 24 newsprint pad, begin to follow the linear edge of the teapot. Begin at the

lid, follow slowly the shape of the outer edge, looking at the object until you reach *a change in the direction of the line.*

Look at your paper now. Start your pencil in the new direction and continue this line to where it joins another line. Whenever this juncture takes place (a line changing its direction), look at your paper and start the new line. If you do this faithfully, even the most difficult foreshortening will take care of itself. To a surprising degree the shape will reveal itself. Often an involuntary distortion will be found in the first attempt. This is not in the least unusual.

Through the distortion one can see the foreshortened shape to be found when one looks *down* upon an object. Also there is the suggestion of projection of the form so difficult to obtain consciously.

Repeat this problem with many individual subjects. When you feel compe-

tent to draw the linear form of objects from any position, then try the arrangement of more than one object in your still life, thus going on to Problem 2.

PROBLEM 2

Set up a still life with variety of size and shape. For example, use a vase, a lemon and a grapefruit; or a sugar bowl, an apple and a banana; or three other unlike forms.

Arrange these so that *the forms overlap each other.* Set against a simple white background the objects you intend to draw. Carefully study their shapes. Look directly at the objects. Do not look at the paper.

Begin to draw the linear edge slowly with Conte chalk #3 on your 18 x 24 newsprint pad. Follow the longest line you see. Go around the outer edge. As soon as you reach a place on the drawing at which the line changes *direction,* look at your paper. Then continue in the new direction. Be sure the drawing is directly in front of you.

·The proportion will doubtless be wrong at first try. Do not be discouraged. Try again.

In this problem, notice when you have set up your still life, that a foreground, a middle ground and a background exist.

The beginning student will ask perhaps, "How can I even approach a drawing in line without a long preparatory instruction in perspective?" I believe the best approach to drawing forms in space (which is what perspective is) is in learning to see.

Think of your drawing as a theatre stage with limits of space. Things must be set in space. You are not limited to the audience view, however. You may see it from your own level, or from above, or from below.

The masters, knowing the limitations of their art (representing in line) made a virtue of this limitation. Their pictures rarely attempted actuality. They made use of distortion and simplification as in the picture on page 25.

For the present, make use of simplification both in setting up the model and in rendering in line. To begin with, draw what you see.

You are learning to see and to draw at the same time. You will notice that often the shapes you draw are exaggerated. They will reveal an emphasized sense of the object in space: its roundness or squareness apparently *project from the paper.*

Repeat this exercise until skill in rendering the linear edge is evident to *you.*

Make the experiment of trying to remember the shape of the objects you have just drawn without looking at these. Work an additional hour of drawing time at drawing from memory.

Memory drawing helps you make drawings imaginatively and releases you from complete dependence on the model as a source of subject matter. Take at least nine hours of drawing time, an hour at each sitting, for drawing from the model.

What one draws is unimportant. An exciting drawing can be made of a cabbage and a dull one of a charging horse. The subject matter is a stumbling block for too many adults in learning to draw. It is difficult for most people to appreciate that line and beauty of form and content may be found in simple objects everywhere, such as in a battered hat, a purse, a group of kitchen utensils, or vegetables on a table.

Elimination of detail is an important key to good drawing. On page 123 there is a simple drawing by Henri Matisse. It is drawing reduced to its essence. A

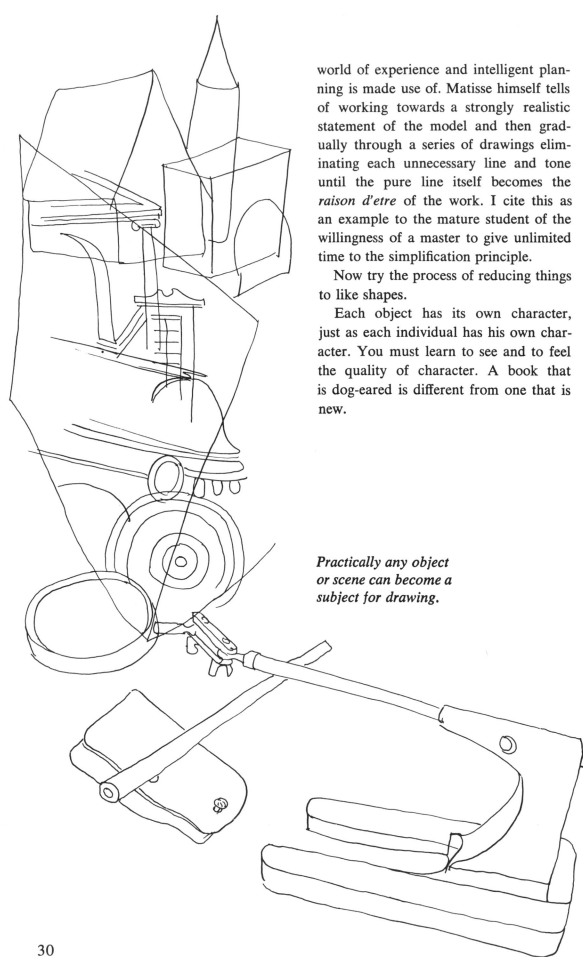

world of experience and intelligent planning is made use of. Matisse himself tells of working towards a strongly realistic statement of the model and then gradually through a series of drawings eliminating each unnecessary line and tone until the pure line itself becomes the *raison d'etre* of the work. I cite this as an example to the mature student of the willingness of a master to give unlimited time to the simplification principle.

Now try the process of reducing things to like shapes.

Each object has its own character, just as each individual has his own character. You must learn to see and to feel the quality of character. A book that is dog-eared is different from one that is new.

Practically any object or scene can become a subject for drawing.

30

An old man is more likely to stoop when walking than a young man. Try listing a set of contrasts apparent to you among similar people and objects: two men, two boxes, two animals.

Character exists just as strongly in *your* drawing approach. Character exists in *your* interpretation. No two people have exactly the same reactions. This personal aspect or individuality of character should be preserved and cultivated from the beginning. There is no *right* way to make a work of art, nor is there a wrong way. I suggest an approach to drawing, but *you* must enter into the completion of the drawing in your own way.

Much has been written on the unimportance of the subject in art. Ten times as much has been written on its importance.

Almost everyone learning to draw begins by emphasizing the story-content of pictures. For example, the beginning student who has good taste admires enormously the frequently reproduced drawing, "La Soupe," by Honoré Daumier. It is reproduced on the next page.

Daumier, besides being an artist's artist, was also popular with the great mass of people. Thousands of his wonderful drawings appeared as cartoons in daily and weekly journals of public opinion. For years, drawings flowed daily from his pen. The sympathy and humour of his work and the simplicity of his design did not prevent a certain grandness of concept. It compares favourably with drawings of Michelangelo. Honoré Daumier made comparatively few paintings, and during his lifetime, received little or no recognition for them. He lived in stark poverty and advancing blindness. Some of the finest French artists of his day, and the most successful ones, were his loyal friends, Corot among them.

Study the drawings of Daumier with understanding interest. Drawings are more than lines on paper skilfully placed. They can be a direct and incisive expression.

The subject of the mother feeding her child may arouse pity and sympathy for the poverty-stricken family group so well described. The fierce protective instinct of the mother, the disorder and meanness of the room, the characters' unkemptness tell their story well. And undoubtedly the major impulse of the artist was to tell just this story.

Not so easily understood is the technical drama which goes on within the drawing. A building of strong forms is made by means of opposition. Significant in this drawing is the use of the linear edge executed with bold lines and telling directness and urgency.

The adult who wants to learn to draw may be extremely sophisticated in his knowledge of drawing. This knowledge may inhibit and frustrate him if he does not put first things first. It is not true that it is easier to draw apples than madonnas except in the strictly story-telling sense.

It is, admittedly, easier to draw from still life. The subject is inanimate. There is time to deliberate. There is time to arrange the objects to your satisfaction. Find out the *character,* the individuality, the quality, of what you are drawing. The impulse to draw stems from that character. Your drawing will have that particular character transferred almost automatically by you to the paper.

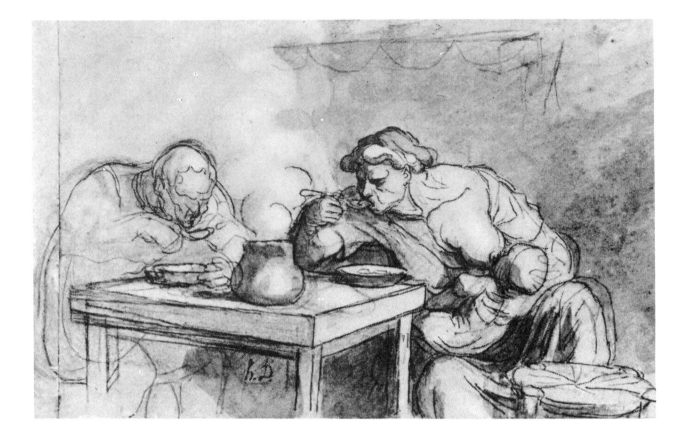

"La Soupe" DAUMIER

*This powerful drawing shows Daumier at his best. The strong forms are
built with a minimum of lines. A feeling of the directness of impulse to draw
is apparent. The subject matter is, of course, compelling and the basic design
quality is never lost sight of by the artist.*

*On the opposite page is another domestic scene by Jean Francois Millet.
Here the power is instigated by a tenderness, almost sentimentality, in the
approach. It is the subject which is important, and the design hardly exists.
The insistence on form is clear, but it is used to enhance the real quality not
the pictorial one.*

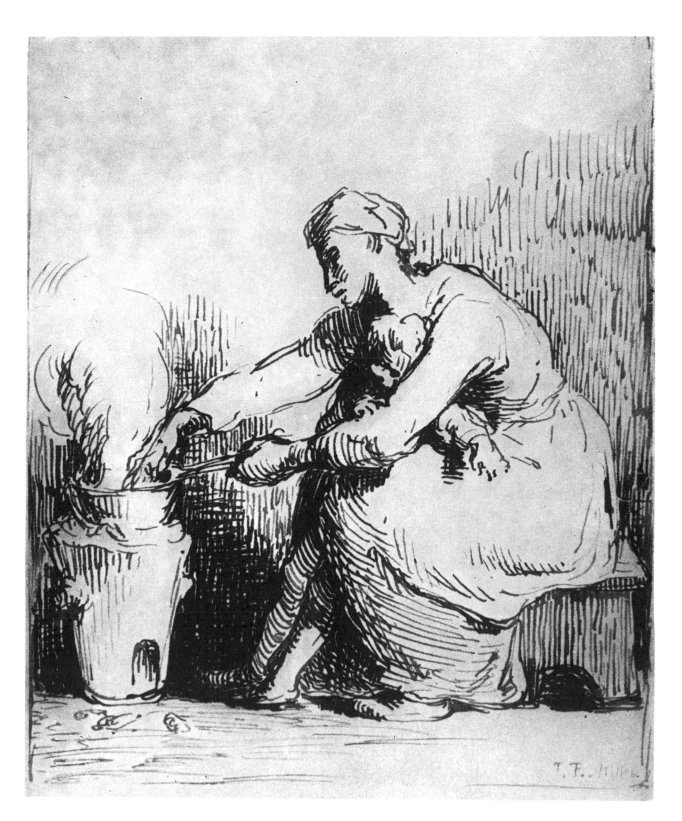

"Woman Cooking"　　　　　　　　　　　　　　　　　　MILLET

33

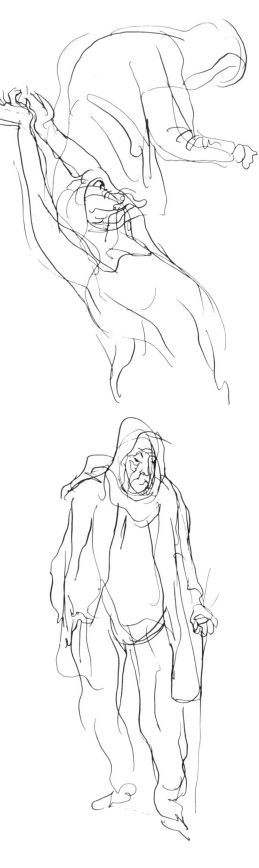

Use of the sketch book cannot be emphasized too strongly. This sketch book notation is important under any circumstances. It is not dependent on available time, but serves for jotting down a movement, line, a group of shapes, or even the behaviour of light. The student should never be without his sketch book.

Page from a sketch book

34

PROBLEM 3 A single object. Suggested subjects are a spoon, a wine bottle, a rolling pin.

Materials: The same materials can be used for all of the following four problems: Newsprint pad 18 x 24; a newly sharpened pencil, 3 B.

Time to be spent on this problem: Two hours in which you may complete two or three subjects, or more. Do not hurry drawings of the linear edge. This problem may be readily divided into two single-hour drawing sessions. An hour of the two-hour period should be spent in drawing from memory.

PROBLEM 4 Objects composed in space: Examples are a box with a spoon and a lemon; or a pitcher with a cup and a banana; or a group around a musical instrument.

Each composition is to be allowed two hours, one hour of which is to be spent in drawing from memory.

PROBLEM 5 The Human Figure: The model standing in varied poses.

Time, fifteen minutes for each pose, with five minutes' rest for the model between poses. Three poses per hour. A two-hour session.

PROBLEM 6 The Human Figure: The model in movement — bending, stretching, reaching.

Time, fifteen minutes for each pose with five minutes' rest for the model between poses. Three poses per hour. A two-hour session.

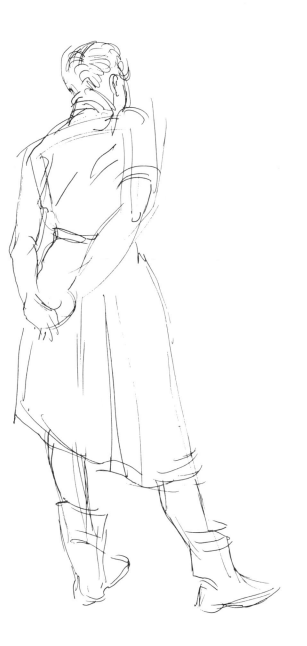

4. THE FORM OF THINGS

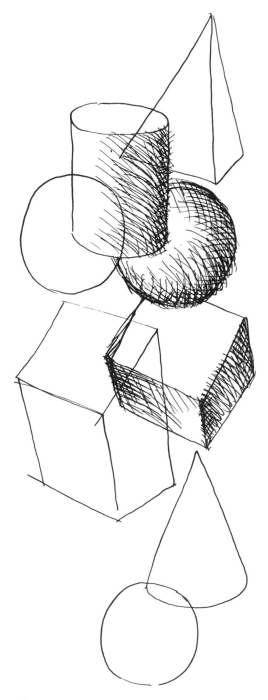

Now that you have explored by means of line the representation of an object, figure (animal or human), tree, or flower, you are ready to explore form from another point of view. To make forms more convincing and more easily understood, artists as early as the fifteenth century—and ever since—have been making use of light and dark in controlled values. Much of Western art, in painting and drawing demonstrates the sense of form in space by these means. It is a convention that is close to our visual understanding of form, for all objects are distinguished in space as a consequence of a source of light.

When an object is lighted from a central source such as a single electric light or, as in nature, when the sun strikes an object from one side, the delineation of form is expressed by sharp contrast of light and dark. For purposes of form realization, this effect is shown and formalized by means of at least three values of dark. The high places of the form are light, and the low or depressed places are dark, with the intermediate places grey.

Tones of dark vary from each other in a measurable degree, or *value*. Dark, halftone, light and highlight are all descriptive of value. Three or four distinctive degrees of dark placed properly on the drawing of a cylinder will communicate the sense of its form. *The sense of form* is the recognizable shape of a thing, a person, a rock, a tree. It is its *weight* added

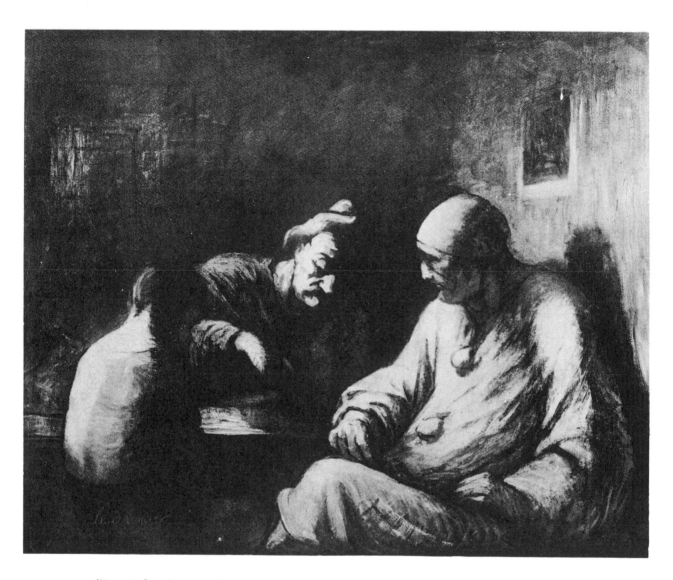

"Les Saltimbanques" DAUMIER

 This drawing is notable for its counterpoint of light against dark and dark against light, so often a characteristic of the pictorial means of this master.

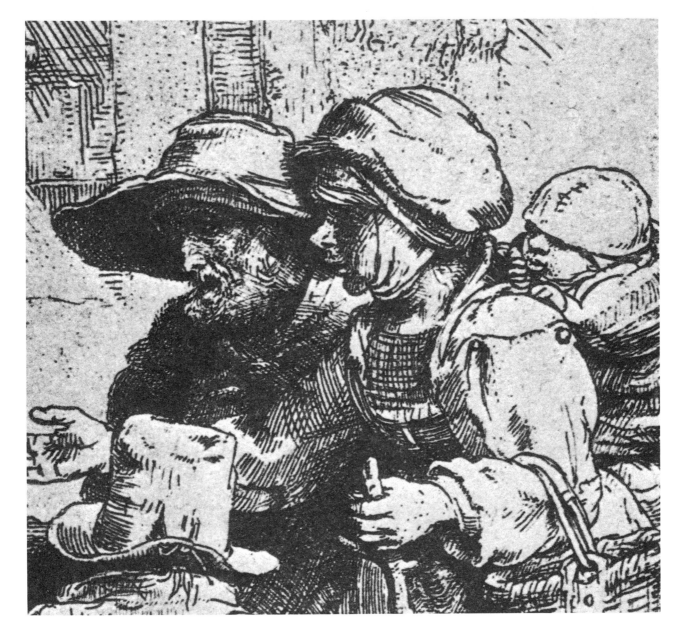

Enlarged detail of "The Mendicants" REMBRANDT
 *In this enlargement you can see clearly the simple means used to express
form and character. Each of the three heads is bent in a different plane so
that one feels ease and naturalness in the figures.*

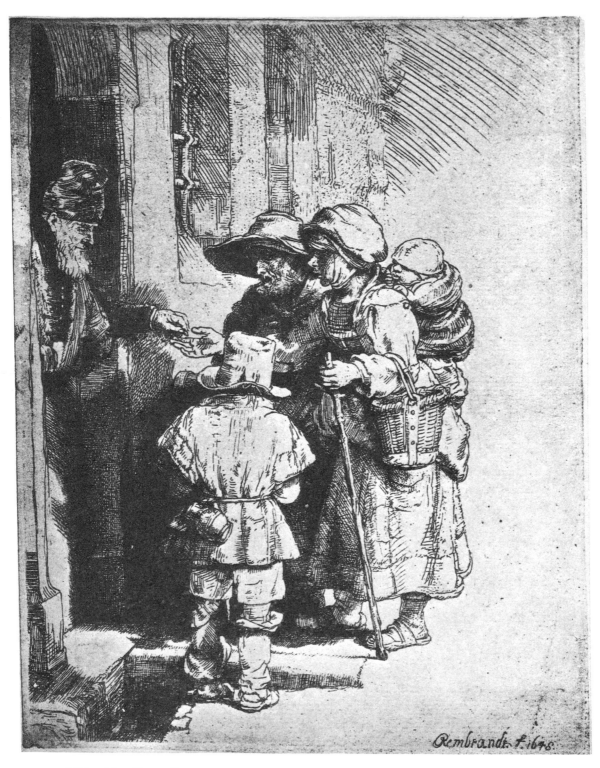

"The Mendicants" REMBRANDT
 *This drawing on copper combines both form and the linear edge. The
dramatic emphasis is intensified by use of dark edges against the light on the
faces, except for the baby's, which is entirely linear.*

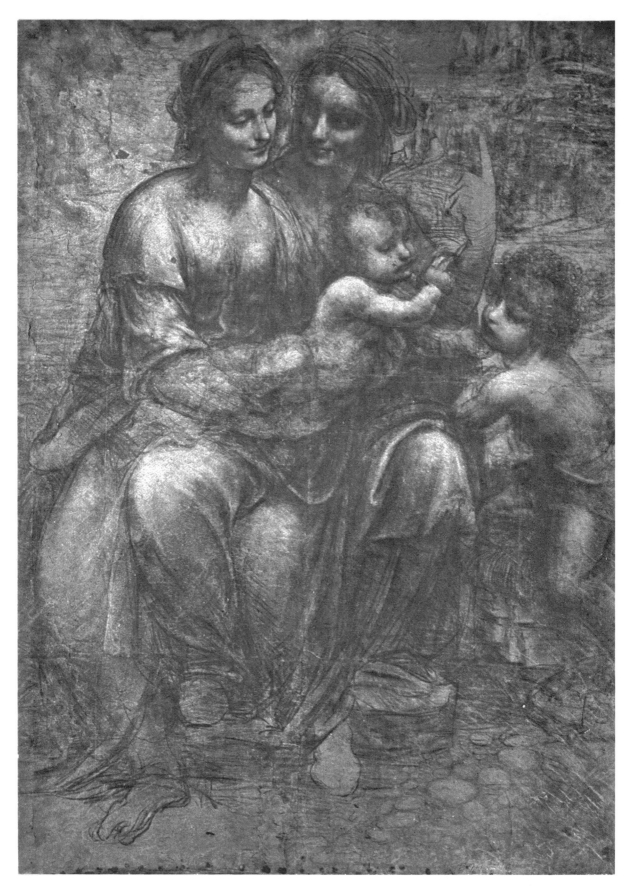

Sketch for the "Santa Anna"

LEONARDO DA VINCI
Burlington House, London

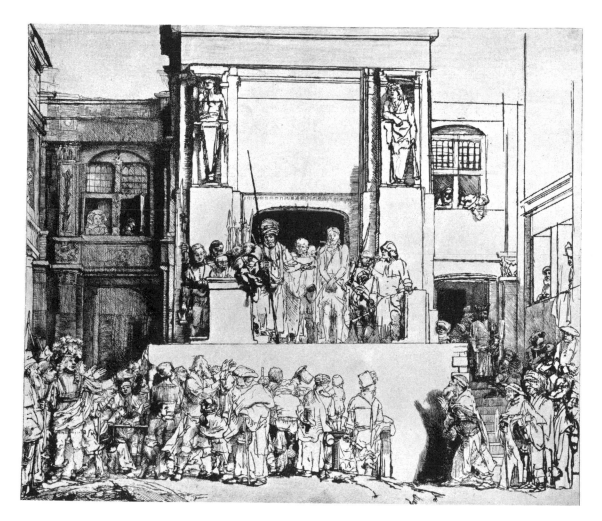

"Christ Shown to the People" REMBRANDT

 The enlarged detail (on page 12) of the lower portion of this masterly etching shows the great simplicity with which the individual figures are handled. It is interesting to note that the figure of Christ is as large as some of the foreground figures and the sense of backward space is conveyed by the different levels on the picture plane, as in Oriental art rather than as in perspective.

to its height and width and depth. It is also what is revealed to the observer when light strikes that object in a particular way.

You can learn to compose with forms as well as with lines. Objects may be placed in relation to each other by means of light and dark to show their place in space. A new dramatic element is introduced by the opposition of dark-valued form against the light, as Daumier so often did in composing his lithographs, paintings, and drawings.

It is almost impossible to discuss form without recourse to the terms of sculpture. One refers to weight, modelling, pressing back forms, and other terms which have to do with the appearance of actual solid forms, but drawing remains what it always is—a set of symbols which is understandable to the observer.

Here is a beginning problem in discovering form by means of the preceding scale of values. Use this scale to indicate degrees of darkness on two simple forms: a sphere and a cylinder.

PROBLEM 7 *Materials*: Newsprint pad 18 x 24, brown Conte chalk, a #4 red sable watercolour brush, a bottle of Indian ink.

Divide the paper in half the long way.

Lightly indicate the linear edge of a sphere in chalk. Leave a circle about ½ inch across at the sphere's middle. Use the brush and ink to go lightly over the half-sheet of paper, except for the spot which you have drawn on the sphere. Use short strokes. You will see the chalk drawing only lightly and as a guide.

Thicken the strokes at the edges of the sphere until the form becomes apparent.

Any stroke or dot or short line to indicate the form is suitable. Among twenty students I have observed that each has a different quality of line or dot with which this problem is executed. It is this difference that is the beginning of a personal expression and should be cultivated. Do it your own way.

Time: Spend two hours on this problem.

Repeat this problem using a cylinder

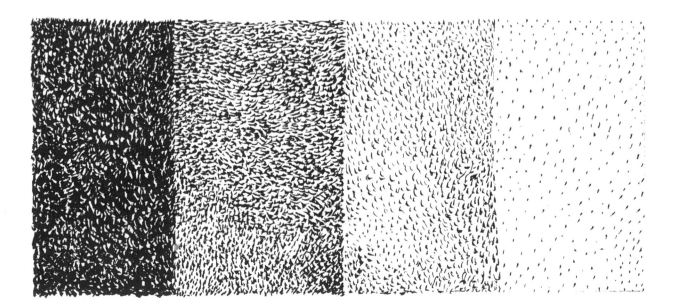

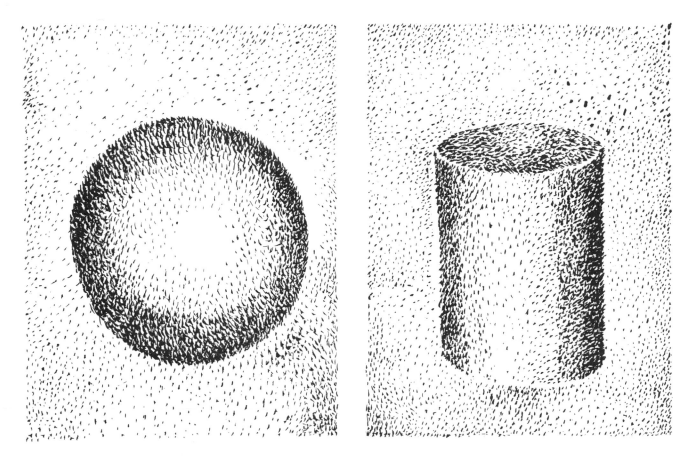

No form can be revealed without light. How light strikes the form provides the key to describing it graphically. By means of simplified light and dark arbitrarily arranged as in the above illustration of a cylinder, the sense of form is made apparent. The use of these tones of dark projects the third dimension.

for your subject matter on the second half of your paper.

Once you arrive at the point where you can draw a single object in space and can give it dimension, learn to relate its form to other forms in space, so that *composition* and *the making of pictures* are integrated.

PROBLEM 8

Try a problem with three objects, dissimilar in shape and size, but all possessed of the third dimension (depth). Place them so they are contained in space.

One object should be placed near to you on the table surface with the other

two behind it. We know from our examination of the *linear edge* that one form will pass in front of another *by means of line*. Forms drawn with light and dark values do the same.

If you possibly can, relax the tension that results from the search for accuracy in finding perspective and correct outline. Concentrate on the form. The perspective will take care of itself. In a later chapter you will find answers to problems in perspective and proportion, but for the moment the problem is only to achieve the sense of form in related objects in composition.

A revealing example of the use of light in the realization of form is in Rembrandt's drawing of "Saskia and Her

43

Child" reproduced on the opposite page. Here is a combination of expressive line and simplified form. This little family memoir—for it is actually a deeply affecting drawing, done tenderly and with pride, of Rembrandt's first wife and child—takes on a different aspect, quite apart from its subject matter, when we examine it as a work of art.

There is grandeur expressed in the upward sweep of the darks and in the insistent verticals. The simple massing of dark on one side builds the form. Dramatically, the artist arranged the dark of the back of the head against a light area. The counterpoint of light strikes the arm of the child, giving meaning to the form, and at the same time, contrasting its design and shape against the dark area.

Three general tones are all that are needed here. We feel the form relieved from its background and placed in space. The light and dark are arranged. It is not a naturalistic lighting—that is, one translated exactly in tone values from the model. It may be it was not drawn from the model at all, but synthesized and simplified in the extreme, in order to express the impulse of the artist—not the visual alone, that Rembrandt saw, but also the *felt* rhythm and design experience.

The artist relived his impression in his work in this instance.

IMPULSE

Impulses should be derived directly from the source. The source may be the model, or it may be one's own imaginative re-creation of things seen and felt. Successive copying vitiates work, destroys original impulse, makes for mediocrity. There is much to be learned from copying of the masters and not all copying is bad, but a drawing, however feeble,

that results from your own impulse or reaction to sight and touch and emotion is more important and valid as a creative work than the best copies of Michelangelo or Rembrandt, and will give you more satisfaction. Copying should be relegated to the field of investigation, which is where it belongs. You must learn by *doing,* and copying is actually *doing over.*

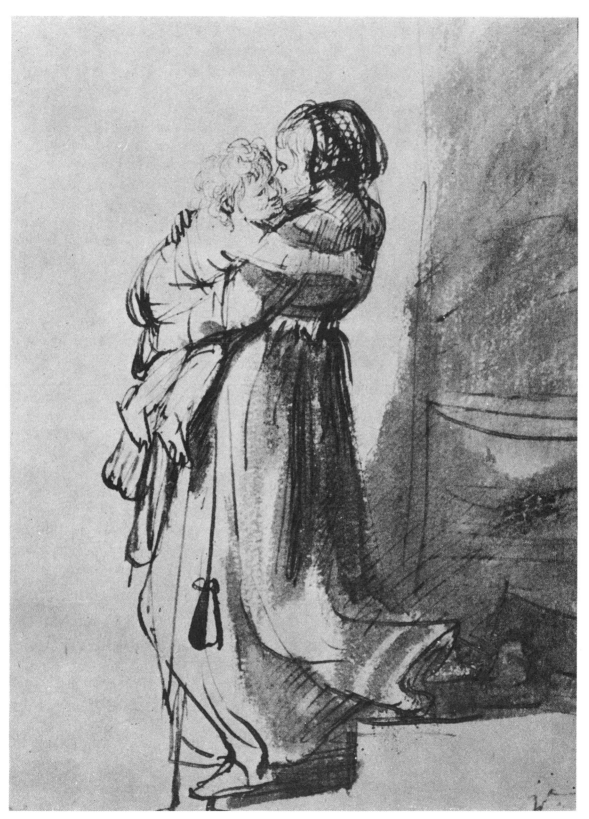

"Saskia and Her Child" REMBRANDT
 This tender, sensitive drawing is a study of Rembrandt's first wife and
their child. It is a characteristic example of the artist's free swift sketches
which so often are wonderful for their instinctive design, arranged by the
simplest of lines reinforced by wash.

On the other hand to study, examine, and to analyze good drawing is both a pleasure and a valuable frame of reference for the student.

It is impossible to make clear the excitement and beauty of drawing without constant visual reference to the masters. The examples that follow are not for purposes of copying, but for your enjoyment and stimulation and analysis.

While it is true a lifetime is too short in which to discover the whole panorama of graphic arts expression, by means of *personal experiment,* we must admit that many of the most original of modern artists spent a good deal of time copying and interpreting the work of the masters.

We find Matisse studying Pollaiuolo, and Van Gogh studying Millet. For a time in the history of art study, the first step was unquestioned copying of examples (not always good ones) to be found in the art schools.

For the sake of analysis then, look at page 47. Here is reproduced one of the series, "Los Caprichos", by Goya, one of many plates drawn on copper and etched. Goya, who lived part of his life in the eighteenth century and part in the nineteenth, produced work that is modern in our time and yet retains ties with the past.

Subject matter is important to Goya, as witness the fierce material he made use of in this series, but never does it become so important to him that the design is neglected. A large black area occupies two-thirds of the plate. In sharp contrast the white of the bandana and of the woman's head is clearly etched against this dark. It is not illustrative. It creates a mood of terror. The face beneath the white bandana is lost in shadow. No features exist on it. The open mouth of the woman is drawn with a single line. Here form and the linear edge are so

mingled that the example can serve to illustrate either concept of drawing.

There is a rich vein of excitement in the life and work of Goya, whose scalpel-like pen probed deep into the excesses and horrors of the period of corruption at the Spanish court during the Reign of Charles IV before 1808. In 1789 he was made court painter. The series, "The Disasters of War," were made of the revolution of 1808. Vital and revealing are "Los Caprichos," descriptions in allegory of this life at the court.

Most of the examples chosen for this book are drawings made with a crayon, pencil or pen, but these of Goya are done on copper with etched line in aquatint. It should be remembered that etching is drawing in another medium.

There is a striking drawing by Honoré Daumier, "Les Saltimbanques", reproduced on page 37. I have chosen it because in dramatic quality it approaches and surpasses the Goya mentioned. This time the drama is contained in the design. The arrangement of the light dramatically clarifies the form.

One figure drawn in the light contains the essence of Daumier's formula for producing form. All the edges are dramatized light against dark on one side. Where the light strikes the wall and comes down behind the seated figure, the dark value is used to define the edges. Across the table is a patch of dark very like that in the Goya, occupying two-thirds of the drawing. The features of the second face are pulled out solely by means of light. As in so many Degas drawings that show dancers in their moments of repose, Daumier chose to show these acrobats in quiet talk over a glass of wine. He reserved the drama for the actual drawing rather than expend it in the dramatic and accustomed attitudes of their occupation.

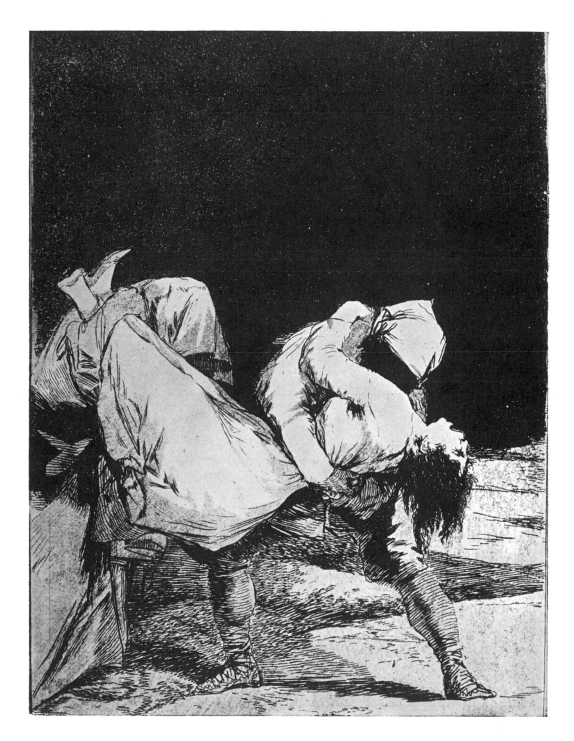

From "Los Caprichos" GOYA
*Subject matter is important to Goya, but never so important that the
design is neglected.*

If you will refer now to the illustration on page 32 of "La Soupe" you will find that the same means for producing form, made use of in the Goya, exists here, too.

In most of the great drawings there is no attempt on the part of the artist to render colour in terms of black and white values, that is, to render red as dark, blue as light, yellow as grey. The reason for this omission—the translation of colour in the drawing—is to preserve the form. It is as if the artist has said to us, I know that the cloak in the drawing is blue, but more important to me is that a living body moving in space is beneath the blue cloak, and I want to render the body's form and weight. Let us allow the colour to the painters who can use both by the nature of their medium.

PROBLEM 9 *Materials*: Newsprint pad 18 x 24, brown Conte chalk, a #4 red sable watercolour brush, Indian ink.

Use the whole 18 x 24 sheet.

Set up a three-object still life.

Draw the linear edge with brown chalk, looking at the model only when you feel the line changes its direction. Treat each form independently being careful to see that when forms overlap you draw only forms that you see—leave out the edges you *know* are there but do not see. Bear them in mind but do not draw them. Model each form. Darken towards the outside linear edge those forms in the model which are round. Also darken the planes that recede and are flat in the model.

Set up at least four compositions, with three objects in each, or more as your skill increases, being certain that your problem remains the same: one that helps you to understand how to build the form. Give it reality, substance, weight.

Time: Spend two hours on each composition.

I have tried to avoid the use of the word *exercise* and to substitute for it *problem*. It is important that you think of the drawing problem as requiring a solution, and that solution the expression of *your own creative idea*, rather than something hedged by formula.

You must take time to clarify your intention. Is it pure form—the shape of things in the round—that you wish to express? Is it the pattern or design, or is it some nameless urge, almost automatic, in which the line takes hold of you and seems to grow into a pattern of intelligible emotion? Actually in learning to draw, all three of these elements may enter at the same time and in the same drawing.

"The world is divided, for me, into two groups, formed respectively of those who care for drawings and those who do not. For those who do care there is nothing so thrilling as a good drawing. . . ." That is the dedication to the memory of Royal Cortissoz, a discerning explorer in the field of drawing, in *The Pocket Book of Great Drawings* by Paul J. Sachs.

The drawings you make are not meant to be framed. They are progressive gropings towards your realization of good drawing.

Earlier I suggested you use the large 18 x 24 newsprint pad. It is inexpensive and you will not mind the quantity of paper you consume. Each drawing should be a new experience. Make as many as you can until you have given yourself a chance to learn. There is endless creative pleasure to be had from drawing for its own sake and with no thought of showing your work for a long time.

Now we come to problems of organized form from the nude or clothed model.

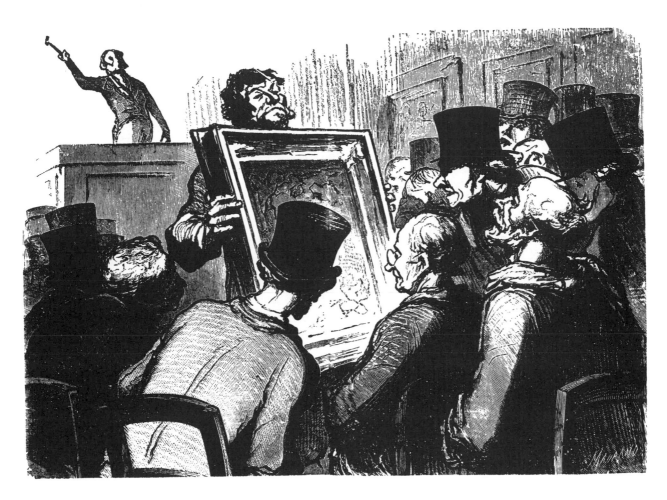

"The Picture Auction" DAUMIER

An important aspect of Daumier's composition here is contrast. Dark masses are placed against light to focus the interest. Note the black top hat used in the foreground against the light patch arbitrarily placed at the bottom of the picture held by the auctioneer.

PROBLEM 10 *Materials*: 18 x 24 newsprint pad, brown Conte chalk, a kneaded eraser.

Seat the model.

Cover the paper with a medium tone of the chalk, using its side.

Draw the linear edge, pressing hard on the point of the chalk, looking at the paper only when lines change direction.

Half close your eyes to look at the model. This will help you choose the main rhythms of the form. Rhythm means the long lines of movement within the form.

When you have chosen these major rhythms, draw the kneaded eraser over the grey tone of the paper, and so "pull out" the light tones of the rhythm.

After four drawings in this technique from the model, reverse the process of choosing the rhythms. Try a drawing of the model by covering the whole sheet as before, not by drawing in the linear edge first, but by pulling out the rhythms in white at the middle of the form.

Then bear down with the side of the chalk along the outside edges of the form in a rhythmic single stroke.

Press towards the outer side of the chalk. This will cause a dark rich edge, graduated towards the light within the middle of the form.

Another variant of this technique is to use grey paper. Draw the linear edge with a brush and Indian ink, and with white chalk indicate the rhythms at the middle of the forms.

Time for twelve drawings: Three hours.

The problems you have just worked out should not lead you to a formula to which to adhere rigidly in each drawing. The creative attitude finds in the subject a reaction and tries to express it with as little attention to formula as possible. These problems are not intended to be worked out to achieve a technical formula for finished drawings, but as the means to learn *how to simplify.*

For someone working on his own, there are the difficulties of obtaining models, nude models in particular, compared with the extensive use of the model in the art school. It must be remembered that everything one sees, everyone who passes by can be considered a model.

Use your family and willing friends as models. Do not try to draw portraits at first. Use what models are available to help you find form and movement. *Simplify.* Simplification is the keynote to successful drawing.

Do not demand that the model hold the same pose for more than five minutes. After five minutes try a different pose. You will find less difficulty in getting your family to pose for you with short poses and you will profit by doing more drawings. Each new drawing from the model is a new experience.

Too long a study of an individual pose is often needless and confusing. Sustained study from the model must be arrived at gradually.

When it is possible to work in a group with other students, pose the model against a dark neutral (grey or brown) screen or wall, in a room with plenty of light. Do not try for extreme lighting effects. Let the natural lighting of the room fall on the model. It is well to raise the model by means of a stand or base about fourteen inches from the floor.

"Two Figures" RODIN
 This is a fine example of the "pulling out" of white areas to articulate
 the movement and to enhance the form enclosed by the linear edge.

5. ARTICULATE MOVEMENT

Articulate movement in a form represents doing, that is, an action completed or about to take place, as in bending to pick up an object, as in reaching for something, or as in kneeling. There is also the "activity" or "movement" of a tree bent by wind, or clouds driven across the sky. Even a road "winds" or "moves" across a picture.

Note that the line that describes or articulates these actions contains within itself the indication of movement both in direction and quality.

I once attended a small auction in New York City. Among furniture, pottery, and antique hangings, a portfolio was quite neglected. Within I discovered hundreds of drawings of the French sculptor, Rodin, who lived and worked in the nineteenth century. The drawings were studies of the nude, simplified to the single bounding line around the form, done with the freedom that only complete mastery of drawing allows. As works of art they spoke eloquently of the relationship between *articulate movement* and *form*. On the opposite page is shown a reproduction of a characteristic Rodin drawing.

The problem that follows relates articulate movement to form.

PROBLEM 11 *Materials*: Newsprint pad 18 x 24, Conte chalk.

Divide a sheet into four parts.

Place the model so you see the whole figure at once. Have the model take a pose that will describe movement such as bending or kneeling. Front view for the first pose; the same pose, but left side profile for the second; the same but right side profile for the third; and the same, rear view, for the last pose.

Concentrate on the articulated movement.

Follow quickly the longest line in the figure. Then put in the opposing lines. Consider them as structure. Feel the movement in the rhythmic stroke. Take the model's position in your own mind. Feel the pull of your own muscles.

Generalize first; particularize later.

Make twenty of these drawings without regard for detail.

An oval for the head and broad-stroke indications of movement alone will suffice. Soon the line itself will take on a rhythm of movement. Scarcely take your chalk off the paper during this exercise. Let the line weave back and forth, following the movement. Now you are beginning *to see and to feel* the creative articulate movement.

Do these drawings with absolute freedom.

Make them as large as your paper allows. Let your drawing be rough and free. Concentrate on the weight by neglecting the details. Place no emphasis on neatness. Work large. Use the whole paper.

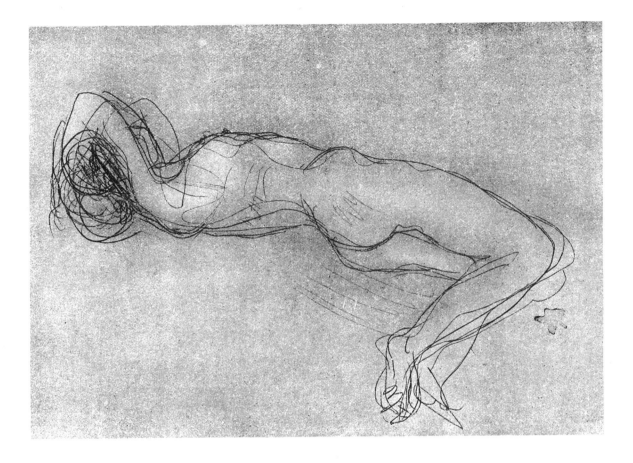

Sketch RODIN
*This is one of hundreds of sketches or notations of movement by the
great French sculptor, Rodin.*

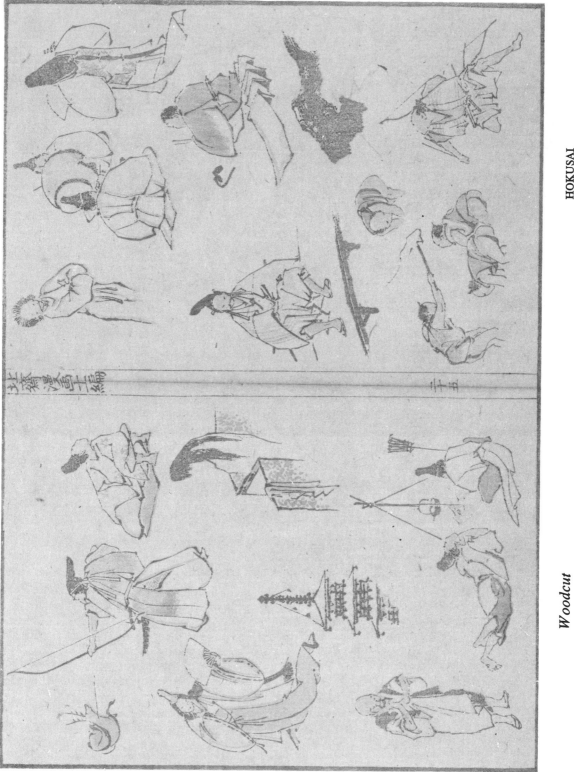

Woodcut　　HOKUSAI
*Like sketches in an artist's notebook, these drawings on wood are direct
and simple in their expression of articulate movement.*

54

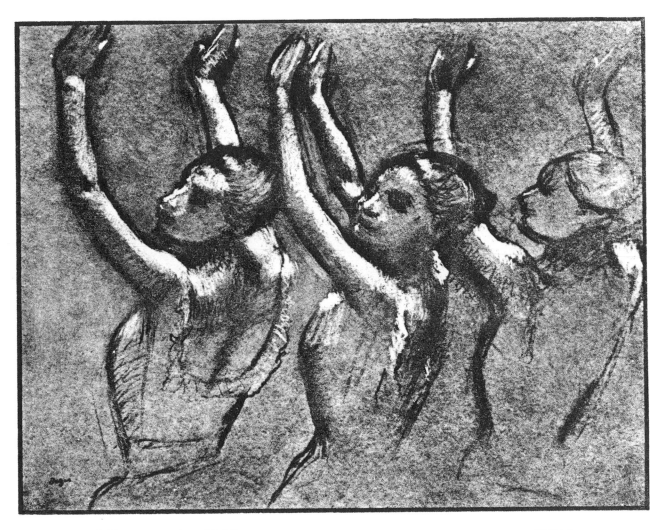

"Three Dancing Girls" DEGAS

The white areas which the artist has "pulled out" in chalk are rhythmically arranged so that the major emphasis is on the designed movement—or articulate movement, as we speak of it.

55

PROBLEM 12 *Materials*: Fountain pen and black writing ink, 8½ x 11 bond paper.

Pose model as in the problem immediately preceding, with pose variations.

Now try to express the articulate movement by means of lines.

Study the Daumier drawing on page 58. Every line gathers energy towards the movement. The line seems itself to be moving. This would apparently contradict the earlier discussion of the elimination of lines in which simplification is achieved by the concentration on movement alone and not on detail. Those lines which reveal the weight and movement are accented with increased pressure on the pen.

The lines apparently drawn with great speed indicate the form without bounding it. This is the painter's approach. The lines are useful only to suggest. We look less for beauty in the line itself. Instead of the crisp linear edge round the form, in this case a new kind of statement becomes clear.

Throw off the restraint caused by the attempt to draw a single correct line. A drawing may be expressive with many lines, and simple in its effect too. Often the eraser plays too great a part in correcting the drawing. Many of the original good impulses are literally erased. It is not necessary to have but one correct line. The form can evolve by means of a gradual approach with many *searching* lines. The first impulses are important, often, because of the bold swing of the lines, in establishing both the position of the design and the rhythmic character of the pose.

Save this by keeping the first lines light in value. As you approach the form, bear down on the chalk to give emphasis.

and by the same token our superglossed present has outgrown or outworn the clichés of Romanticism, and substituted for it one of its own: *abstraction*. Yet no matter how divorced man may become from reality, nor how much he strives to busy himself in theory of design and abstract shape, his major interest must remain man.

It is this very concern that causes so many of his efforts in drawing to relate to the movement, design, and drama of the human figure.

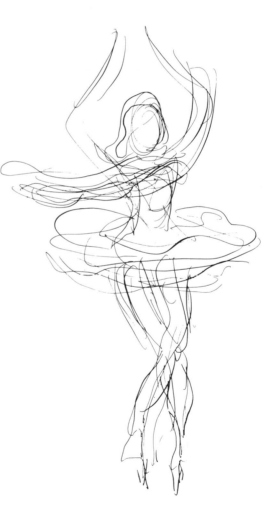

There may be many of you who want to learn to draw and yet have no interest in drawing the human figure. To direct your study to the drawing of the model exclusively would cut off a whole world of subject material. But the drawing of the figure with its wonderful changing line and movement remains a never-ending source of interest and challenge.

Let nature *be* the source. Look for articulate movement and character of shapes. It is probably true that "bored civilizations crave the distractions of ornament," as Sheldon Cheney states,

57

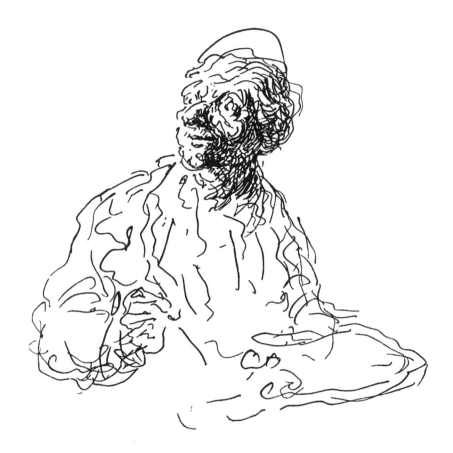

"*Un Type*" DAUMIER

The form can evolve by means of many searching lines. The first impulses are important because they establish by bold swings both the position of the design and the rhythm of the pose or expression. The Daumier drawings on the opposite page exemplify the same technique.

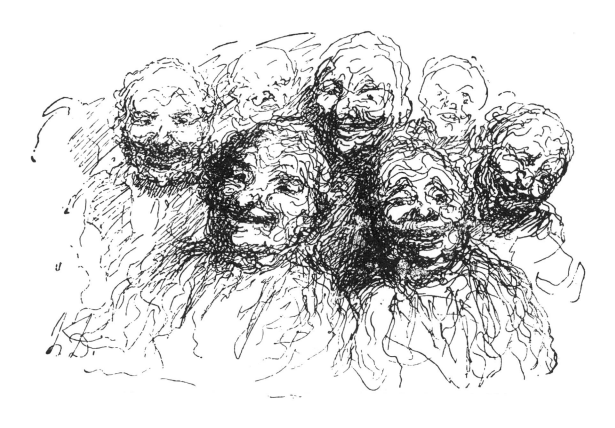

"Laughing Heads" DAUMIER

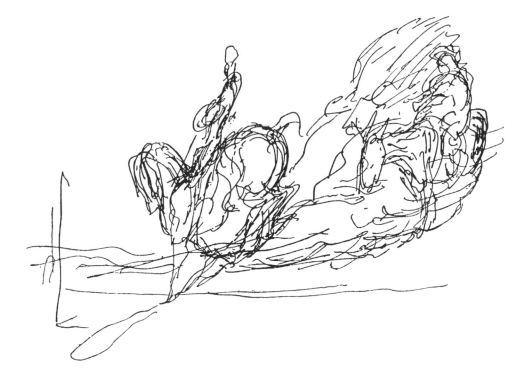

"Don Quixote and Sancho Panza" DAUMIER

6. STRUCTURE IN DRAWING

A sense of security in drawing comes from a knowledge of structure. With long study the anatomic structure of the body can be learned by any student, but the desire to draw cannot and should not be inhibited, and the student's impetus to draw must not be retarded until that time.

Let us, at first, consider anatomy only insofar as it will help along the way towards creative drawing. No long memorized lists of names of muscles and bones are required to begin with. It is perhaps impressive to name and describe muscles and their attachments in Latin. More important than this, however, is to remember where in the figure bumps and depressions occur, how the leg bends to support the body, or how the leg straightens, how the torso folds accordion-like on one side and pulls to a beautiful curve tightly stretched over the bone structure on the other. We should note, for example, that at the ankle the knob of bone is high on the inside and low at the outer side.

LEARN TO SEE

You should learn to draw the structure as a unit. Do not think of hands as being independent of arms, or of the head as independent of the neck and body. Rather feel the function of each in the human whole. If this principle is learned, proportion will come as natural knowledge and there will not be the fear

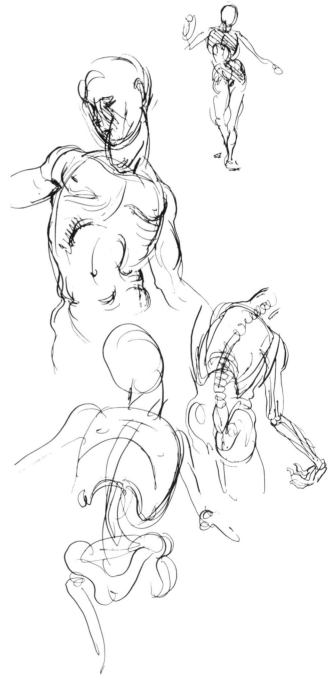

60

of distorting, occasionally, for purposes of design, for it will be done deliberately. Really to know the figure is to be able to make convincing its movement and proportions as well as its individual parts.

THE OUTER SHAPE OF THINGS

Having learned, then, to see the figure as a whole, the next step is to learn its parts, still bearing in mind the whole form and its proportions.

For purposes of study the body may be considered as having these divisions: the head and neck, the shoulder girdle, the rib cage, the pelvic girdle, the spinal column, arms and hands, legs and feet.

The movement of each part and the relationship of one part to another is valuable only insofar as the whole figure seems convincing. Too often the student is so intent on drawing the head with its wealth of sensitive detail that he neglects the structural form of the neck and so misplaces it on the shoulder girdle.

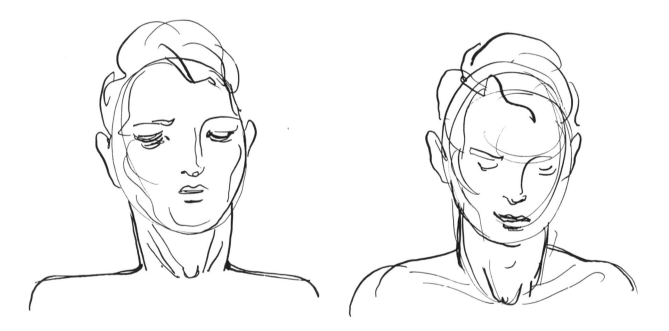

a common error

it should look like this

This illustrates only one of the pitfalls of drawing the detail to the neglect of the whole.

61

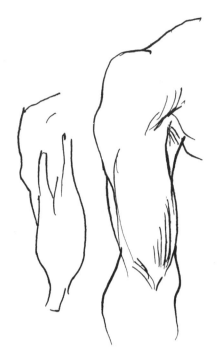

relaxed

As you work with the model before you, you may find that many of the structural aspects of the figure mentioned in this text or in an anatomy reference book may seem more difficult to find on the model than in the clear linear anatomy drawings. It is because variation in shape and proportion is the rule rather than the exception in anatomy.

The search for character is the search for these differences. Find them and express them.

For purposes of clear comprehension English terms are used here so far as possible: jawbone, cheekbone, nose bone, etc. . . Where a Latin term is necessary because its English equivalent is less well known, the former is used.

On the opposite page are the main masses or forms of the human body in (a) full view, (b) profile, and (c) back. This is the bone structure of the human figure. Next are shown the major muscles, that keep the body upright, that draw up the arms and pull them down.

Some muscles perform more than one function and each has its complement. For instance, the forearm is pulled up by biceps and down by triceps. All muscles work by contraction. This is important to learn and to observe because in drawing contraction changes outer form. The shape changes when movement takes place.

All measurements of the body are modified by perspective. If we look up at the figure we see one set of proportions. If we look down upon the figure still another set of proportions prevails. And of course any movement of the head or the figure also changes proportions visually.

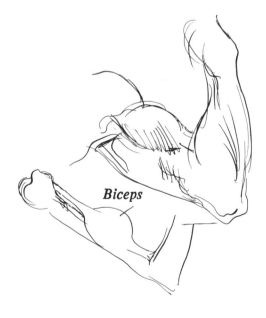

Biceps

in action

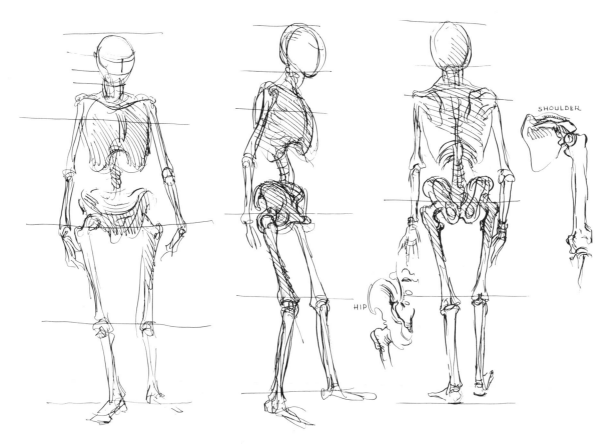

SHOULDER

HIP

Above are shown freely drawn masses of the bone structure; below, the muscles are shown.

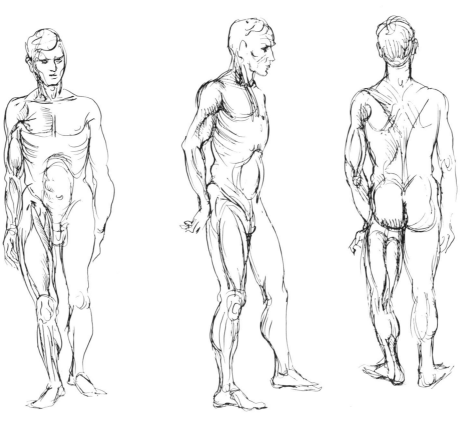

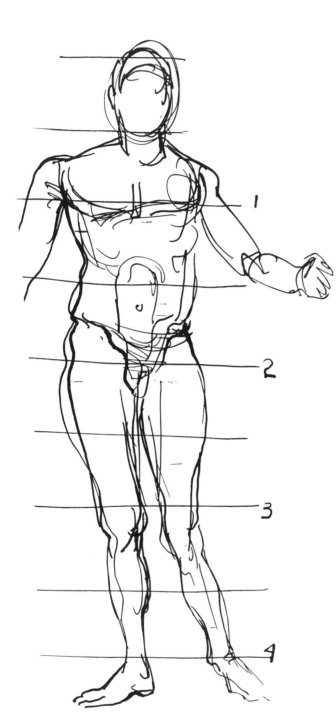

Roughly the upright figure divides into four parts. Since variation is the rule rather than the exception in nature, constantly refer to the model so that you do not become slave to the rule. There is no substitute for going to the source. Let character find its way into your work. If a figure is tall, lean, or squat, exaggerate whatever quality it possesses. The proportions are only a first guide. And instead of marking out proportional lines first, draw the whole figure roughly, then lightly check the proportions by means of these three lines, one across the breast, called the pectoral muscle, another line at the crotch, and another at the knee.

The figure movements are limited by the backbone. Except in anatomic charts the figure is never symmetrical. Changes of weight, and the consequent upsetting of symmetry, take place when the body is standing at ease or is in leisurely or violent movement. The pelvic or hip mass will bend and also the chest mass. With these changes come corresponding changes in the arms and legs. One should feel one's way into the movement by a succession of lines.

We must put our limited anatomical knowledge to work for us at once. We do this by simplification of the forms and by concentrating on the movement and proportion of the whole figure.

Further to check the proportion, divide the top fourth into halves.

This will approximate the size of the head.

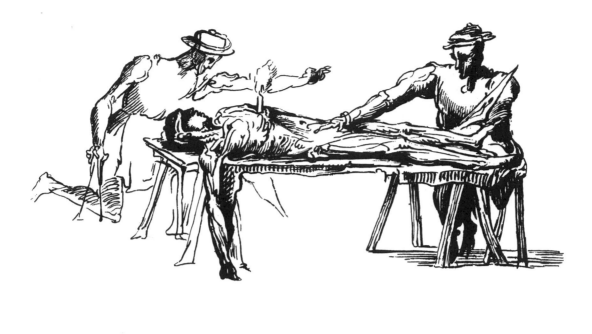

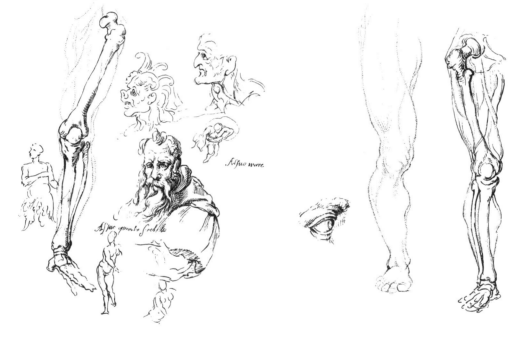

Drawings MICHELANGELO

 These show Michelangelo's interest in and understanding of anatomic
structure. The upper drawing shows a dissection at a time when such an oper-
ation was against the law and could have subjected the student to severe
penalty.

Another method of arriving mechanically at the proportions of the human figure is the measurement by which the head is used as a determining factor in proportion. The usual formula is seven and one-half heads to the length of the figure, with eight heads a bit closer to the modern ideal.

This and other mechanical methods have the serious fault of making the student depend upon them to the detriment of his power of observation. Besides which they halt the rhythmic search for movement.

The value of learning proportion is to help make a figure drawing convincingly alive. It is not an end in itself. Anatomic structure and proportion are inseparable but in themselves will not make a masterpiece. They are tools which must be subordinated to the impulse to draw *vitally*.

PROBLEM 13

Draw the simplified lay figure in a free manner. Try its proportions by the seven-and-one-half heads formula. Now set it to work for you. Make it bend to pick up something. Make it walk, run, sit and stand. Fill a whole sheet with these sketches. Remember, in order to give them the quality of movement you must yourself feel the action the lay figure is to take. Walk, run, sit and stand if these are the actions you draw. Feel the walking, running, sitting and standing movements.

Time: Two hours.

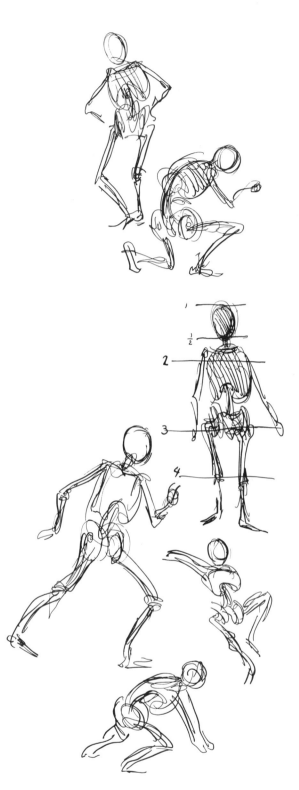

PROBLEM 14

Make a study of the manner in which the head is set on the shoulder girdle. Observe the column of the neck and draw it in profile, full view, three-quarter view.

Study the movement of the head as it bends on the neck.

Time: Two hours.

Watch the lines of direction. Some of the most beautiful rhythms are contained in these lines of direction. Hogarth, the English painter and graphic artist, living in the eighteenth century, devised a formula that he called "the line of beauty." He found it by tracing the rhythm of a human backbone and reducing it to an abstract line. This is interesting, particularly, because no one ever gave more thought to subject matter than Hogarth. Sometimes his work seems to be more literature than painting. But even the literary Hogarth saw the necessity for reducing to abstract terms certain elements that obtain in the figure.

The hipbone which bears the weight seems higher than the one that does not. The shoulder slants towards it. Try placing your weight on one foot. In your mind take the pose of the action and try to draw it at once in simplified form. Observe action everywhere. Put it down with simplified form.

The backbone connects the rib cage with the hipbones, or pelvis.

This muscle is called sartorius or the tailor's muscle.

This is most important to us as it shows an indenture in the line of the thigh.

The head turns on the neck by means of two strap-like muscles that attach at one end back of the ear from the mastoid bone and at the other end to the collarbone.

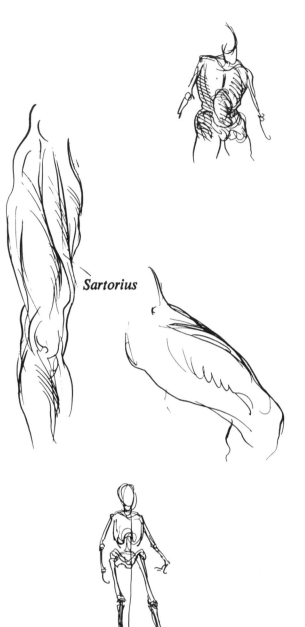

Sartorius

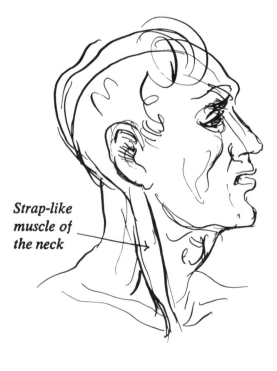

Strap-like muscle of the neck

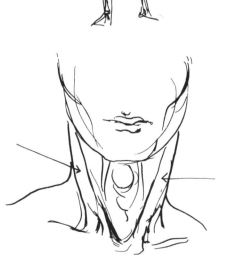

68

The action is what must be expressed, not the static quality of shapes or muscles. Feel the movement. Transfer it naturally. If you are drawing a figure pulling a rope, act out the movement. Feel the muscles pull in your own arms. It will clarify for you the mechanism of the movement. This is by no means a new thought for artists. For centuries artists have relied on this synthesis of action and of expression to produce their work. It is true, just as well, of facial expression. Leonardo gives explicit rules as to the drawing of the muscles of the face and what happens to these muscles under the emotions of pain, fear, laughter. And his drawings were made out of his own experience.

Do not take an experience at second hand. Certainly not from another drawing.

Feel how the face contorts under certain circumstances. That feeling ought to be transposed on paper as closely as you are capable of doing. Often the camera will catch perfectly an expression that seems to portray true emotion. This is a guide not possessed by early artists. The thing to remember is that when you use a photograph as a guide it is still only that—the emotion must still be experienced—*felt*—by you to be realized.

Treat the lay figure as underpinning in your early drawing from life. As you will require more information anatomically, you will probably want to refer to Bridgman or to some other complete anatomical reference work.

Keep anatomy in its place. Don't let it become an end in itself. Remember you can give a lifetime to the study of anatomy and never produce a single truly creative drawing. Go around the whole figure as a sculptor does. Observing various movements and positions leads to

more knowledge and the eventual freedom to say what you will want to say.

We should organize our knowledge of structure so that it works for us as a whole. Try, in the beginning, to draw the whole figure each time. Emphasize some part or feature, but be aware that it must be subordinated to the whole. If you do this faithfully, you will not have to hide hands behind the back or in pockets in your drawings, or stand your figures in deep grass because you find details difficult.

The major bones of the leg are called the femur or thighbone, the tibia, which is the shin bone, and behind it the fibula. From the front they look like this: \longrightarrow

At the joint between the femur and the tibia there is a small bone in the middle of the kneecap. This joint is explained in the illustration below:

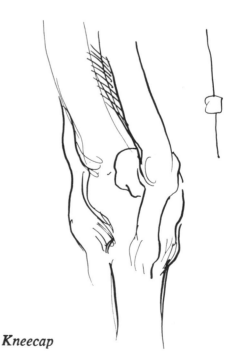

Kneecap

70

In drawing the foot, watch the bone at the inside of the ankle. It is higher than the outside bone and from the back you will see it somewhat like this:

Notice how the foot is wedged into the bones of the ankle.

At the back of the heel a long cord comes down from between the calf muscles and ends around the heel itself. This long cord is called the Achilles tendon. The foot form in profile is a very perfect arch with the heel set in back and the toes forward as illustrated.

As you progress to further anatomical study you will want to know how the ribs fit into the sternum or breastbone, what happens when the two bones of the forearm, the radius and ulna, cross each other as the hand lies flat or turns upward.

My experience has been that students have immense curiosity about these mechanics. They believe and I do that knowing these adds to your assurance in drawing. Such study will take long hours, and if you have the time, study by all means. When you can go to a good source book, try to understand that its value to you lies in that final assurance. No amount of copying will give it to you.

You must apply your knowledge of structure to each drawing you make. If you can, occasionally check your drawings if they seem wrong to you. Use some of the simple factual material I have outlined. Use your knowledge of the bone structure which you may superimpose in a different colour ink or crayon over your drawing.

You will find that your tendency will be to look at the model and to see anew. One learns to look for different values. The direction and movement of a line may seem more important to you at the moment of drawing than the shape of the

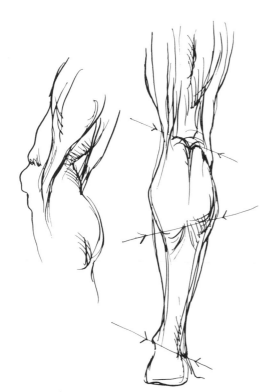

outer bone of the ankle. By holding to your original concept you may make something far better as a work of art, far more telling as a drawing than if the correct form were followed. Freedom to draw rhythmically and meaningfully must never be inhibited, even by well understood and frequently practised rules.

Femur

Tibia

Fibula

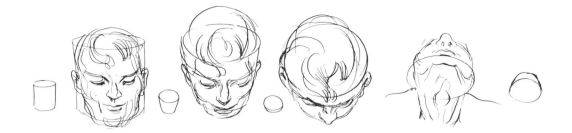

THE HEAD

The head is so important as subject matter in drawing and so often used alone in drawing that you are justified in giving it separate attention. But even with this separateness as a starting point you must consider the whole.

Character is sought and found in differences. In the beginning just try to realize the form of the head. Don't become confused by the features. Keep to the simple form:

Always draw the head from life in these studies. Don't try to make a portrait. Think of the head as a solid shape varying somewhat in form. Generalize. Study the size of the features in relation to the face. They probably take up much less space than you imagine.

Roughly, one can divide the head into thirds. Then, if you divide the lowest third in half, the mouth is placed at the dividing line. The eyes find their place in the upper part of the second third. Generally speaking, one finds the features contained in the lower two-thirds of the head.

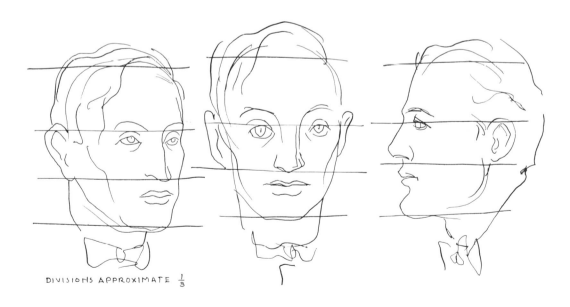

DIVISIONS APPROXIMATE $\frac{1}{3}$

three-quarters full view profile

These generalizations may be helpful:

The nose is wedge-shaped and projects
from the main plane of the features.

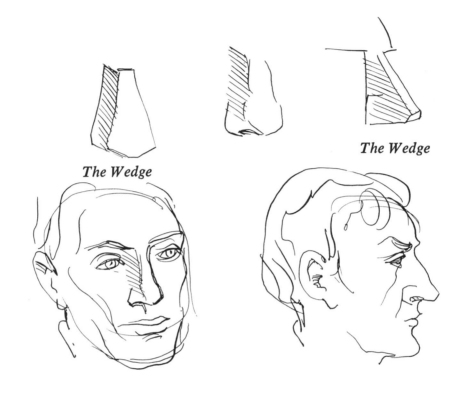

The Wedge

The Wedge

Actually the mouth is not parallel to
the plane of the cheekbone but appears
as on a cylinder which is caused by the
shape of the teeth.

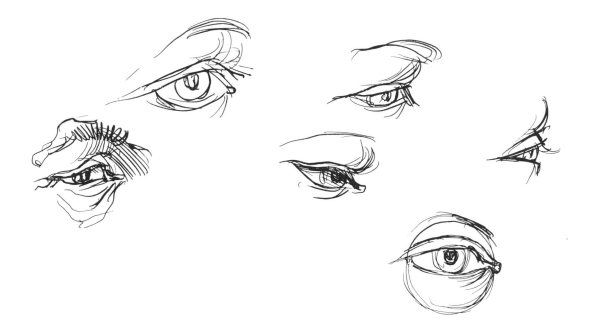

The eyes too go round the head. When we bear this in mind it helps us to realize the round form of the large mass of the head.

Some logic is required to see that the relationship changes as the head shifts and bends. No formula can possibly control or explain all the variations. Once again you must study the model. Some explanation of variation is found in the fact of foreshortening. Foreshortening is the diminution of planes as they recede in nature or in the picture plane itself. For instance,

PROBLEM 15

Draw a cylinder tipped forward. Measure width but not length. This shortening of distances visually, although not actually, is foreshortening.

Learning to see where foreshortening occurs in drawing means to make yourself aware of line relationships.

A line ends and another begins a new form and direction. Learn to observe where this happens. Relate forms to each other by means of line as on page 73.

Notice in the illustration that as the head is tilted the features seem to shorten or lengthen. For instance, as the head tilts back the nose seems shortened, and at one point the tip of the nose actually passes the line of the forehead. It is this relationship, changing with the movements of the head, that causes foreshortening to take place.

THE FEATURES

In drawing the features make this experiment: Draw the whole head large on the paper. Give emphasis to the particular feature you are studying. In this way you will absorb the relationship of feature to head and will not neglect the whole form.

The Eye:

Usually one thinks of the eye as almond-shaped. Variations without number exist in the eye shape. A few are noted here, not for the purpose of copying these but to send you to studying the model directly.

75

One should learn to understand the form and function of the eye. The eye is a ball within an upper and lower lid. The upper lid of the eye is like a shutter. It opens and closes and varies with the position of the head as to shape, as well as by muscular control of its own. Learn to look for changes of shape due to position and watch for individual character. The eye often takes a particular direction. In some faces it may slant upwards and in others down. Follow the particular line it takes when drawing, since it contributes much to the character of the face.

The Ear:

The ear, an instrument for hearing, is more or less cup-like of necessity, and rarely flat against the head. Look at it from the front and profile. See it first as a simple oval, then look at its more detailed structure. Ears vary enormously. They are almost as variable as fingerprints. Here are some variations:

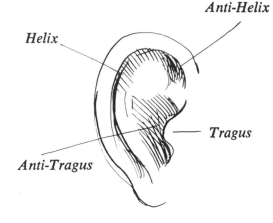

You are concerned not only with the external shape of the ear but also with its attachment to the head. Is the ear close to the head, or does it stand away? How far back does it seem to be on the skull? These questions must be answered from close observation.

The Mouth:

The mouth presents innumerable variations. In drawing, it is most important to follow the lines that describe the opening between the lips. Since this contributes to the varying expressions of the face, follow closely the linear edge of the form and you will note that these lines are never straight. The formation of the teeth

Some variations of the human ear

76

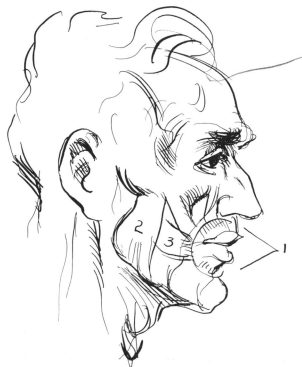

1. *Orbicularis oris, the round muscle of the mouth.*
2. *Masseter, the chewing muscle.*
3. *Buccinator, or puffing-out muscle.*

The musculature is not too difficult to understand in the mouth. Three muscles are mainly concerned with the movements of the mouth: They are *orbicularis oris, buccinator* or bugler's muscle which puffs out the cheeks, and *masseter* or large muscle of the jaw which is used in chewing.

causes much of the variation and change in character of the line.

If you look at the jaw from the point of view of structure alone, you will find it presents a cylindrical shape in its front view. The mouth follows the roundness, so that this

and not this

is to be seen.

A method of proportioning the head, copied from Leonardo da Vinci.

77

"Portrait of His Wife, Agnes" DURER

 This very telling drawing makes use of the linear edge to describe both
form and character, and even texture. The folds of the arm give a real feeling
of cloth. Despite the generally realistic aspect of this drawing, design is also
important in its concept.

"Anne Boleyn" HOLBEIN
 The drawings of Hans Holbein the Younger always search out the linear
edge of the form and are wonderfully suggestive of weight and character.

7. ORGANIZATION OF THE DRAWING

In the studio I often hear students say "I love to draw but I must draw *from* something. I have no imagination." What the student is saying is that he has not yet learned to think in terms of picture *making* but is searching for an idea in order to tell a story. This is a purely literary approach to drawing.

In order to arrive at a pictorial idea the easiest way is to start with something seen or remembered and to build from it. For instance, you can probably visualize the outside doorway of your house. Begin with this—the *shape* of the doorway.

That rectangular doorway is the shape around which you will build your picture. Whether you place the doorway in the middle of the paper or to one side or the other is a matter of your choice, and immediately with the making of this choice you leave behind strict representation and embark on what is most essential in every picture: its design as a whole.

Rules are mechanical and at best are only measurements. It is sometimes better to discard them entirely as we did in drawings of the figure. Later, they serve in critical analysis of your picture, but before all else, your natural instinct to design must be given a chance to assert itself.

You cannot create a composition by a set of rules that tell you (1) what sort of shape to make use of, (2) where to

The shape of the doorway

use contrast, (3) how to give dominance to a particular object. That is to say, you cannot create a picture with warmth and interest entirely by rule.

To come back to the doorway, it may have within its frame a figure stooped and bent with age. Essentially this is

story telling, and you are making a comment on life if you include the figure. Where you place the figure, how you dramatize it by means of lighting—both these are technical matters.

If you are completely able to transfer your emotion only by means of line, form, and arrangement—that is art. The literary connotation is absorbed in the technical and emotional. The resulting drawing needs no title or caption to make clear its intent. One must bring perception to a drawing as well as take something from it. Just as two people never see the same image in exactly the same way, a drawing will be interpreted in different terms:

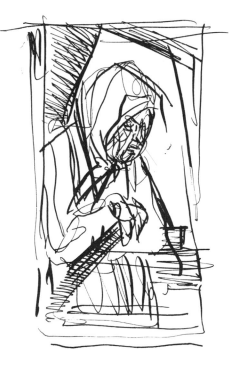

another will draw the mood

one will draw the story content

while another will search out the abstract values

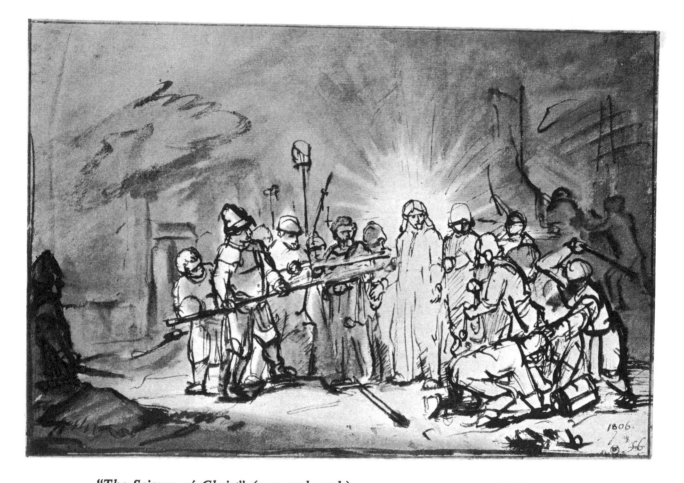

"The Seizure of Christ" (pen and wash) 　　　　　　**REMBRANDT**
Stockholm National Museum

　　What an enormous sense of activity and expressive understanding of the drama is in this sketch. Suggestion by a minimum of lines perfectly focusses the attention to the figure of Christ. Note the direction of the pikes in the soldiers' hands and the stick on the ground leading the eye back into the pictorial space.

Two landscapes (woodcut prints) HOKUSAI

 These prints are by a great Japanese master and show the Oriental con-
cept of pictorial space. As one moves upwards, distance is shown without
resorting to perspective views.

"La Coiffure" DEGAS

*This is really an abstraction in which the angularity of the arms and legs
is made to function as part of the design, independent of the more obvious
subject matter.*

"Woman Seated" TOULOUSE-LAUTREC

*Here the use of rhythmic lines reinforced by values of light and dark
makes a pattern of interesting, even dramatic, shapes in an otherwise common-
place subject.*

If you base your composition or arrangement on something experienced or observed the material will be simpler to handle than something of an imaginative character.

Scrupulously leave out everything you can do without. Working with something seen becomes only a matter of suppressing unnecessary details. Rearrange so that the subject is dominant. Don't let the eye move out of the picture. The eye must travel within the space of the drawing.

SUBJECT MATTER

If we examine a great number of drawings from different civilizations and earlier times we are struck by their immense variety. Some are illustrative and describe happenings or ideas. Some are descriptive of places and people and others are important because they show action or movement. Still others express the feeling of the artist about some thing or some idea.

Obviously the artist must select. But the materials of good organization or composition are to be found everywhere. Van Gogh found interest in a pair of old shoes and a commonplace chair. Michelangelo chose The Last Judgment. Degas enjoyed drawing dancers and race horses. Renoir drew his friends and family. The long-ago unknown artist of the caves drew charging buffaloes. Chagall drew the stuff of dreams. One thing all these have in common is that whatever they drew or painted was something out of their own experience or feeling.

Look around you. See things freshly. Search for the character in lines and in people. Nothing will seem strange as a

subject for drawing. Sometimes when you begin to draw you will start with a dominant feature and relate the less important parts to it. For example, on my table beside my writing paper I see a bowl holding brushes. I draw this first. Behind it, in the next plane of the drawing, I see other objects and I use selected parts of them to help design the whole area. Because I began by concentrating on the dominant feature, it holds the pivot of attention, even though the other secondary objects in line fill the whole area of the drawing.

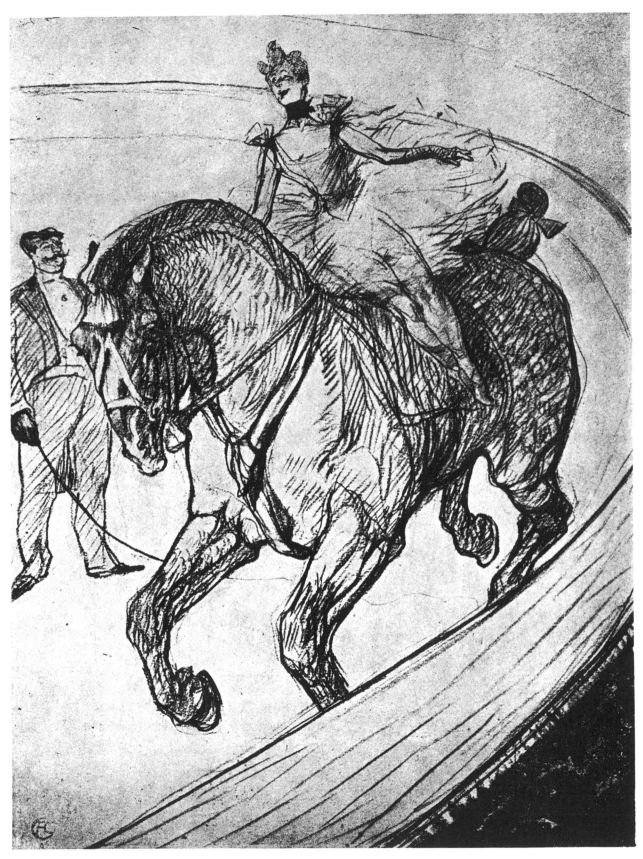

"Equestrienne" TOULOUSE-LAUTREC

87

ORGANIZING THE MOTIF

1. *Eye path*. In organizing drawings there are a few basic principles which you may make your own in order to organize more skilfully. For example, the lines in a drawing ought to direct the observer from subject to idea and from pattern to plan without allowing him to stray from the area of the picture.

2. *The balance of shapes.* For purposes of interest, shapes should vary in size and kind. Variety is a necessary ingredient of organization.

3. *Rhythm* is obtained by repetition of similar shapes or lines.

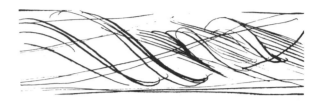

4. *The principle of dominance* refers to a shape to which the other elements of design are related but subordinated.

5. *The entire space should be used.* This has been pointed out as important in design and is reiterated here.

6. *Contrast in lights and darks* is another element in design.

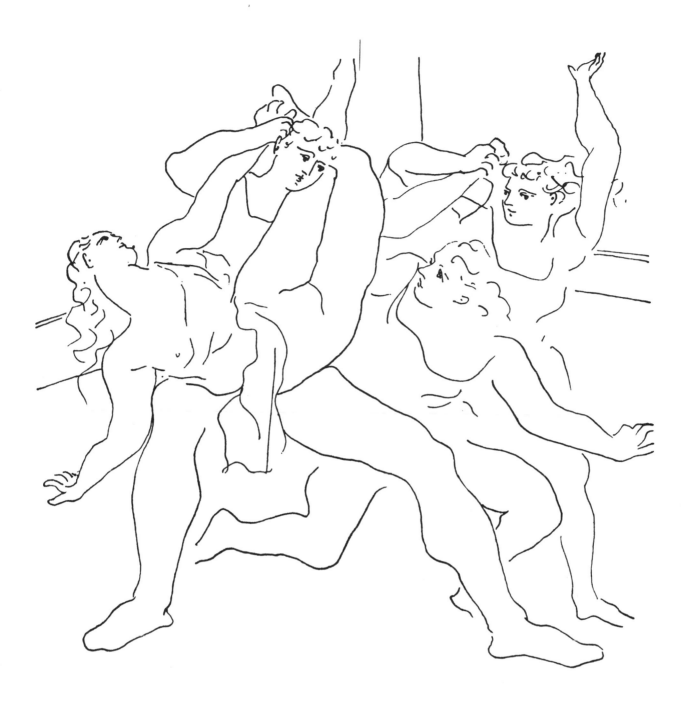

"The Dancers" PICASSO

 *You can actually follow the movement of these dancing figures, so skil-
fully has the moving line been handled. And Picasso has not neglected the
designed space so important in drawing. The figures are composed entirely of
undulating lines, but these are contrasted by straight lines indicating the planes
of the wall and background space.*

"Antony Greeting Cleopatra" TIEPOLO
 This is an example of wash and pen done in the manner of Baroque painting, with extreme skill in the arbitrary or designed use of the wash.

90

"Soldier on Horseback" DURER

91

If you are careful to compose your picture, bearing in mind these basic rules, soon organization becomes instinctive and second nature. Selectivity and arrangement are not so conscious as you may think at first.

Often the word organization is used to supersede the older term composition. To organize is really the work of the artist. The elements may be found in objects or in human beings or even in ideas. But the way lines and forms are distributed on the paper and where and what to put in or leave out—this is *organizing the motif.*

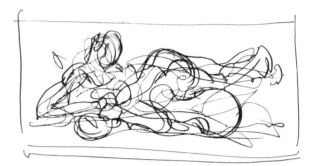

ANOTHER KIND OF COMPOSING

Sometimes a composition may take form by free association of ideas. Begin by freely moving your chalk within a given space on the paper.

Develop the movement into a suggestion, then carry on by adding, more consciously, stroke upon stroke until the composition takes on a purposeful form.

The above is a particularly interesting form of exercise and one that is practised consciously or otherwise by most artists when searching for a pictorial idea.

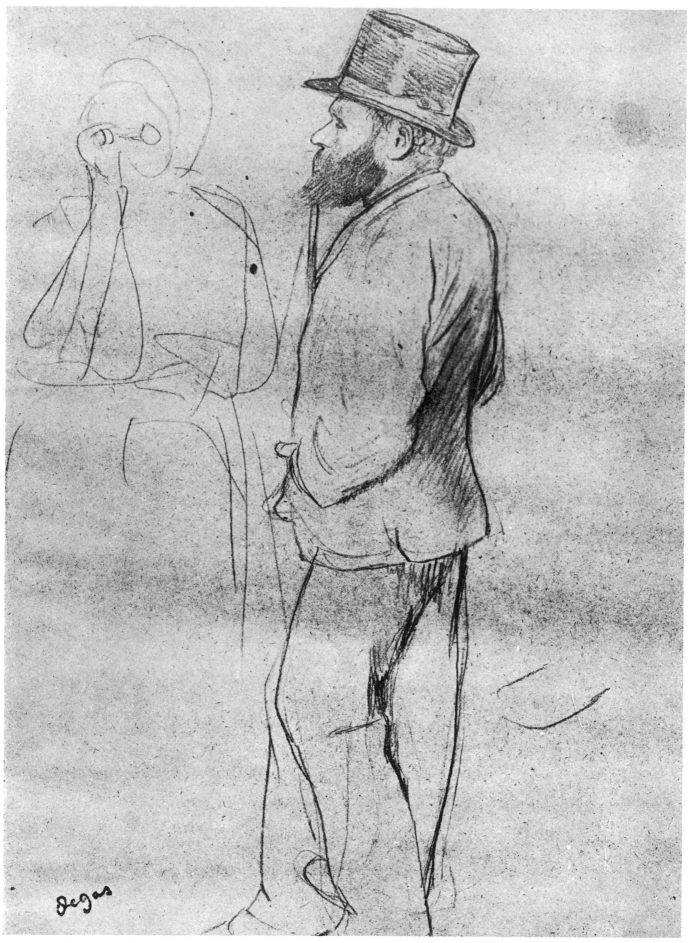

"Portrait of Manet" DEGAS

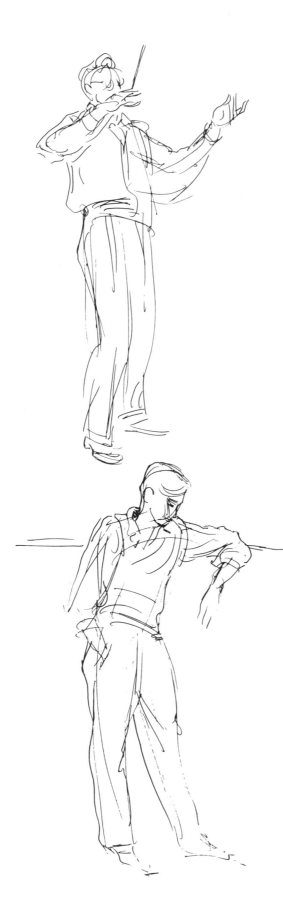

DRAWING FROM IMPULSE

Long before real skill in drawing is yours, you will find yourself impelled to put down on paper rhythms and movements out of actual experience.

Let us relate this impulse to drawing the figure.

You see a figure dancing. Given even the greatest skill in drawing, it is difficult to remember with exactness the details of the hands, the line of the neck, how the torso bends and where. Instead you are aware of movement and an impulse to express it on paper. This impulse is one of the great keys to art. Be conscious of it and quickly expend it on paper because this first feeling of movement can suggest more of remembered rhythm than you would believe possible.

Put yourself in the way of such impulses. Look about you. See how people stoop and stand, how they lean for support, and how they brace themselves for lifting. All these common movements are as fascinating as the dance or the violent movement of athletic sport. They will provide you with an endless source of subject matter.

You will learn to sense the rhythm in a tree, feel its branches stretching outwards and downwards. You will sense it in architecture. Buildings soar into the sky. They hug the ground or vary from the true perpendicular. Even still life must relate movement.

The drawing proceeds from the inside to the outer or visual. This is not mystical or obscure. As a practical approach it is a facet of drawing too often neglected by the student. In the analysis of what drawing is, all the aestheticians and technicians and artists agree that the ma-

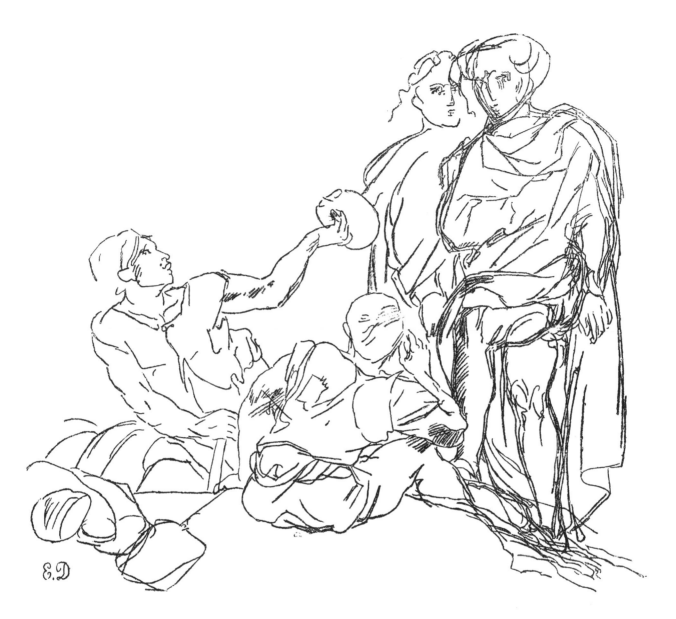

A Sketch for Hamlet DELACROIX

 All the common movements of the body, how people stoop and stand, how they reach and lean, how they brace themselves, are as fascinating as the dance or athletic sport. In this sketch, observe how the artist has caught the sense of movement on the impulse of the moment.

jor quality of a good drawing lies in this approach.

Subject material is everywhere. There is little question that some things move us aesthetically and emotionally and make us feel that we must put these reactions on paper at once before they are lost to us.

It is also true that you sometimes begin to draw and almost automatically the lines build up. Related lines grow upon the paper and they satisfy us in the creative sense. So much of art comes from the inside that it is hard to define the specific point at which conscious composition takes place.

Someone once asked Picasso how he had made one of his paintings and he replied, "First I put down some pink and then I thought of something that would go well with it."

The same can be said of a drawing. It is important to put down the first line, then relate the others to it.

DRAMATIZING

I think composition and organization of pictures are greatly aided by constant drawing. Use a fountain pen to draw objects, figures, and buildings in groups. Carry a small sketch book, bond paper in a pad, or loose sheets clipped together to a board. Use it daily. Try to use nature as a source. Don't be satisfied with a second-hand view of life from others' pictures and compositions.

Try dramatizing your subject by unusual perspectives. Look down on a group of objects or look at them when they are above the eye level.

Until Cézanne's day, one would have thought it difficult to dramatize an apple.

If you draw your observations on your sketch pad in linear edge, you will find these no more difficult to do in unusual perspective or in dramatic foreshortening than in usual ones.

Of course, pictures are not designed by means of line alone. Elements of form must also be considered. The Italian word *chiaroscuro* describes the arrangement of light and dark in the picture. The dramatic quality of form relieved by light against dark is a pictorial formula used by Daumier and Goya to great effect.

Almost all of the drawings by Daumier show an instinctive adherence to formula. It is as though he saw the drama in human terms and expressed it in a counterpoint of light against dark at the edge of the forms. Over and over again in his drawing one will find emphasis on an expression or attitude made clear by the device of the dark silhouette against the lighter area.

The principle of dominance that we examined earlier is apparent. The eye is quickly led to the character expressed. It is allowed to remain long enough to feel the emotion thoroughly. Then the eye is led to the other elements that support the design in a kind of counterpoint.

Try to work up a composition of this sort yourself.

Set up a still life with two objects of similar colour but different shapes, one somewhat smaller than the other. Entirely disregard colour. Draw both as though the form is the important element. Press down on the chalk at the point where the edge of one form passes the other. On the other form keep the light at the edge. This emphasis is not unreal lighting, but it is an attempt to show form quality and to give dramatic feeling to the simplest subject matter. In this way you will learn that the concept of the drawing may be dramatized even though the subject is unimportant. Certainly no story content is expressed and the contrasts alone are sufficient to hold your interest.

Experiment with an organization containing two figures. Here again give emphasis to the light and dark contrast on the forms.

Now try the same experiment with two heads.

Light against dark organized.

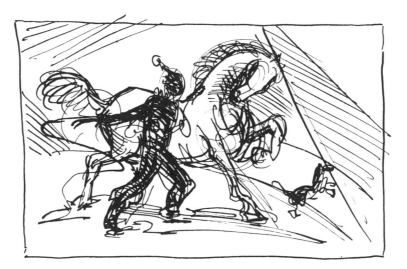

A darkening of the dominant in contrast to a large light area.

8. USE OF PERSPECTIVE

It is quite possible to make a convincing drawing of forms in space, such as buildings in a landscape, without knowing the first principles of perspective. In such a case the drawing simply follows the linear edge method, described earlier, of seeing things as they are.

You may test the principle of this by looking through a window pane. The edges of the pane confine your view and the seen objects take their place in planes that are not too hard to transcribe on paper. The first fact that becomes clear is that near objects are large and objects of equal size diminish as they recede.

This is true of persons and buildings alike, so that if you see a person standing near a doorway in the first picture plane or the one closest to you, he appears large. In the second he seems smaller, but the proportion to door remains the same, while the third shows the same proportion and is still smaller.

In most Western art since the sixteenth century, perspective is used in a more or less scientific manner. There are mathematical formulae to tell you with exactness how much a form diminishes in size as it retreats into the picture plane, and I am sure there are instances in which such information is of great importance.

But, for purposes of beginning drawing, a few simple principles can be used. For instance, the horizon line is imaginary but few representational pictures can do without it. The shape of an object will vary as one sees it either above or below the horizon or eye level.

98

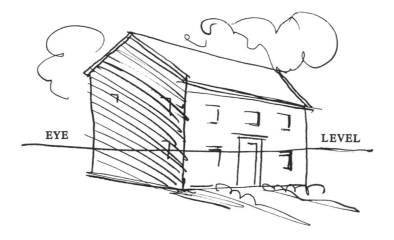

EYE LEVEL

The above illustration shows a house partly above and partly below the eye level, a position usual in drawing.

Visually, lines converge as they recede from the eye. Remember that, theoretically, perspective drawings can be made from one viewpoint only, but that drawing in a creative sense often makes use of more than one viewpoint, and that sometimes it is necessary to distort both perspective and proportion in order to produce expressive effects.

Simple examples of perspective should be tried often: a street lined with buildings, a building of uncomplicated form tried from different angles, a drawing of figures in the street. Relate the figures to the buildings. If your figures are in the foreground you will have a perfect example of how forms diminish in size as they retreat from the eye. If your eye is close to the figure, a doorway twenty feet away from that figure seems far too small to admit it.

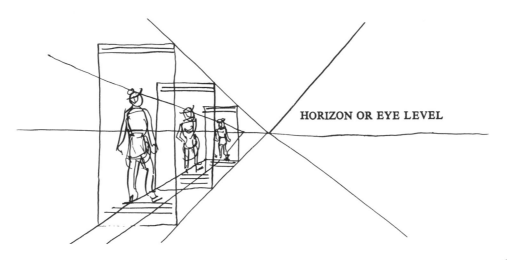

HORIZON OR EYE LEVEL

When you have learned these simple relationships, try to express height or depth without relying on formula, but making use of what you see and feel.

depth

height

closer to you. It establishes a relationship that solves many problems for you in the early stages of organization. This is only a reiteration of the optical fact that as things are farther from the eye they appear smaller.

If you draw a line through the middle of a figure and decide that this is where your horizon line can go, you may then use the same point for figures farther back on the picture plane or for those

H - H -

The horizon line passes through the same point on each figure.

100

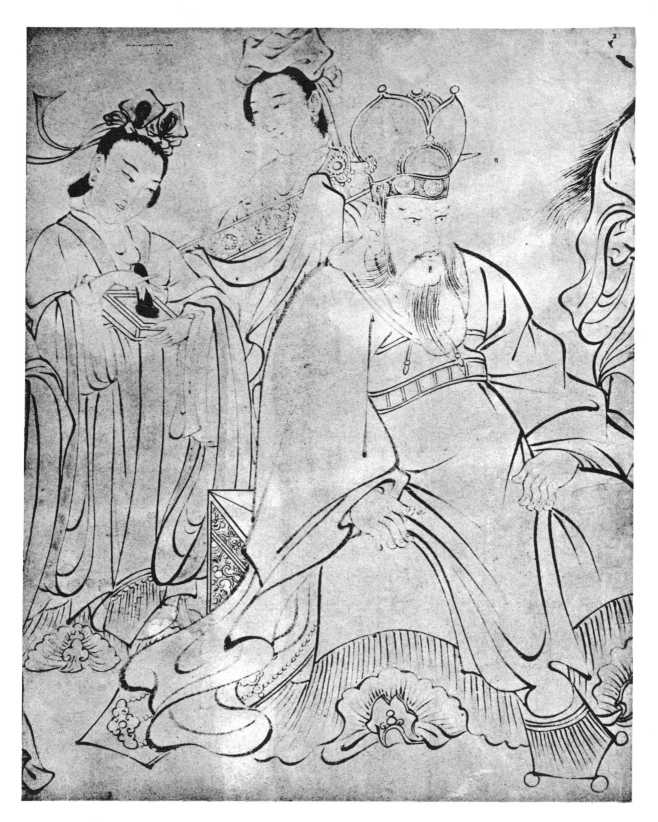

"The Presentation of Buddha"—detail from a scroll WU TAO-HSUAN
This shows use of space with no attempt at perspective, but in spite of this a backward movement of planes is apparent in the placing of the rear figures which are shown to be higher on the picture plane.

101

9. OUTDOOR SKETCHING

So much drawing is concerned with representation that we must give time to it in this book.

The impulse to draw is often prodded or inspired (whichever term you prefer) by a desire to remember how we felt about a place or thing or person.

Let us use a tree in the landscape for an example. At the end of the year we see a great white oak and feel impelled to record it. We can attempt to draw it as it is. Simplify the form. Draw the texture of the bark. Naturalize the lighting on trunk and branches so that the roundness is felt and a sense of form is apparent. Allow the branches to thin out in size and number as they reach into the sky. This is one approach.

Or, sit before the tree, far enough back so it can all be seen at once. With a pen, search out the linear edge of the forms of trunk and branches, starting at the roots, following the forms slowly, watching where the direction of the branches changes, how some come towards you in space while others retreat, until the

Study of a tree LEONARDO DA VINCI
 Some branches are forward and others are back in the picture plane. To convey the feeling of solid form in this drawing is Leonardo's major interest.

"The Lonely Tower" COROT
This drawing conveys a real sense of movement and mood. It is an impression and relies little on design to achieve its result.

"The Little Devil's Bridge at Altdorf" TURNER

 *Here is a dramatic use of the opposition of light against dark to project
a mood rather than form. The scheme is not unlike that of Daumier. The
medium here is mezzotint, a form of etching which lends itself to many grada-
tions of dark.*

whole abstract reality of the forms becomes clear.

Feel the power of the structure as you draw. Search for the character in the movement of the great branches. Notice the movement upwards or downwards.

It is this insistence on feeling the form which will give character and individuality to your drawing. Try to draw many trees and allow yourself to enter the *mood* of the tree.

Some trees have a quality of lithe movement in their branches. Some are stiff and uncompromising and thin-branched. All are studies in rhythm and expressive line.

In summer when the leaves cover much of the structure, trees present another form problem.

You must — at all times, however —

see the whole shape of the tree, and at the same time you must also see the form structure on which it rests. See the leaves in great masses. Do not detail them. You will find the same in-and-out quality of form in the leafed tree that was present in the visible branches. Do not go to the drawing with a preconceived notion of what the shape of the tree is, but see in each the big simplified form of the particular tree you are drawing.

Relate background material to the tree. Find the lines behind and in front that suggest the forms of hill and grass. Remember that the tree grows within an environment. It does not stand alone. It pushes its way out of the earth and the root structure begins to be seen at its base.

I chose here to go into the drawing of trees at some length, but rock formations are equally interesting. Draw stumps of

trees and bits of fences. Buildings in con-
struction are always full of exciting new
shapes and forms. Everywhere around
you is material for drawing.

Sometimes trees will suggest geometric
shapes in their whole design. A tree may
seem triangular but a triangle is a flat
plane and the tree is not flat but conical.
You must feel your way around the cone.
Use these simplifications as clues to the
real form but do not be misled by too
much reliance on formula. Try to see a
tree or shape as though you are evoking it
on paper for the first time, through your
own eyes and with your own sense of
form.

"St. Catherine's Hill" (*etched line*) **TURNER**

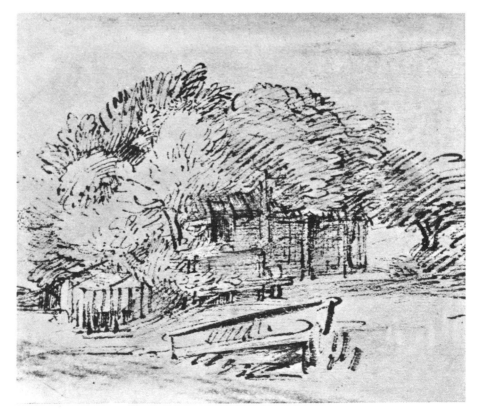

"Farmhouse beneath Trees" **REMBRANDT**

108

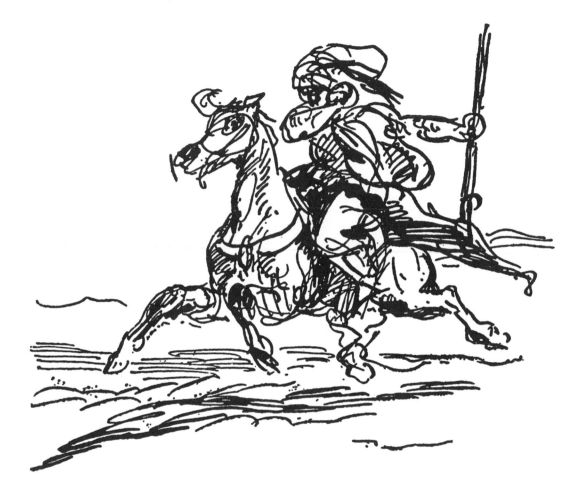

"Bedouin on Horseback" DELACROIX
This is suggestion coupled with character. The movement is most important.

10. DRAWING ANIMALS

There are a great many ways to approach the drawing of animals. The one I recommend is not conventional but is sound in concept and will help the beginner in his mastery of underlying principle.

Animal drawing is like all drawing. It has no separate category in art. Professional artists specializing in this field have been making more or less successful attempts in recent years to render the outer aspect of the animal with almost surrealistic detail. One remarks of such drawings "That cat is so real you can almost stroke the fur," and "Look at the eyes of that dog. He looks so sad." These are purely literary concepts and relate only to story content of the picture. As people are sentimental in their attachments to the pictured animals, they demand no more from the artist than that the conformation or appearance of a

horse or dog be like that required at a horse or dog show.

The kind of drawing that has art content is the one I want to emphasize. Let us look at one so we can discover other values than those described as literary.

The most commonly used subjects in animal drawing are, of course, the cat and dog, since these are most easily obtained as models. Let us start with the cat. When first we began to draw the human figure we drew with broad free strokes to represent the characteristic movement, then over these broad strokes we drew the linear edge pulling the line over the edge of the form.

PROBLEM 18

Wait until the cat takes a quiet pose and then quickly describe on paper the free strokes of the movement. Think of the pose and try to express the catlike quality of it. With the point of the Conte chalk draw the linear edge of the form. Make your studies not too large, and make many.

Your drawings will not show the quality of the fur. They may not even be individualized so that a particular cat can be recognized but they will show what the cat is *doing*. You will *feel* its "relaxedness" or its contained spring, or movement. This is the important aspect.

If you draw the cat in many positions and from many angles, you will learn to

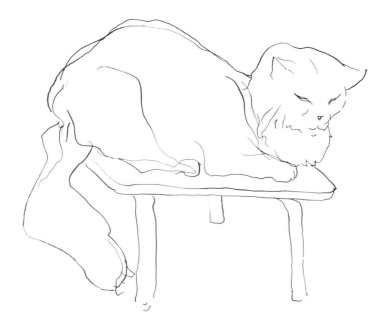

111

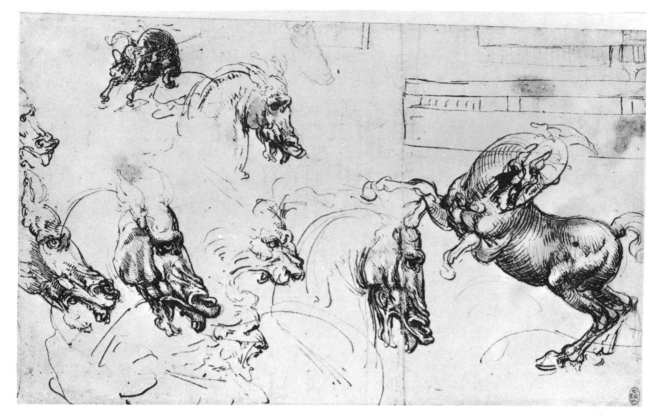

Studies of horses, a lion and a man's head LEONARDO DA VINCI

Studies of tigers and a small head of a woman DELACROIX

112

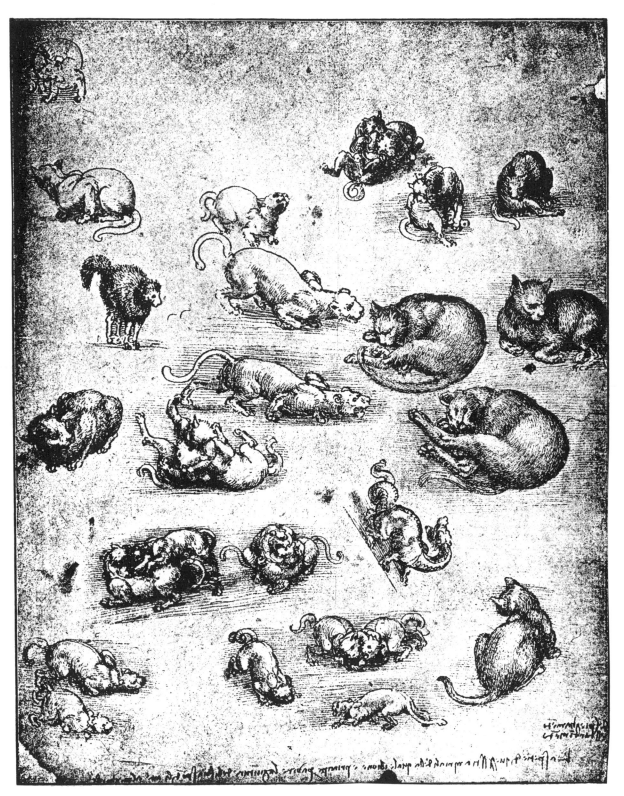

Cats in movement (The Windsor manuscript) LEONARDO DA VINCI
This page is one more instance of the versatility of the great Renaissance master. A panther and a dragon find themselves in the company of some house cats. The insistence on form and movement is the key to the quality of these drawings.

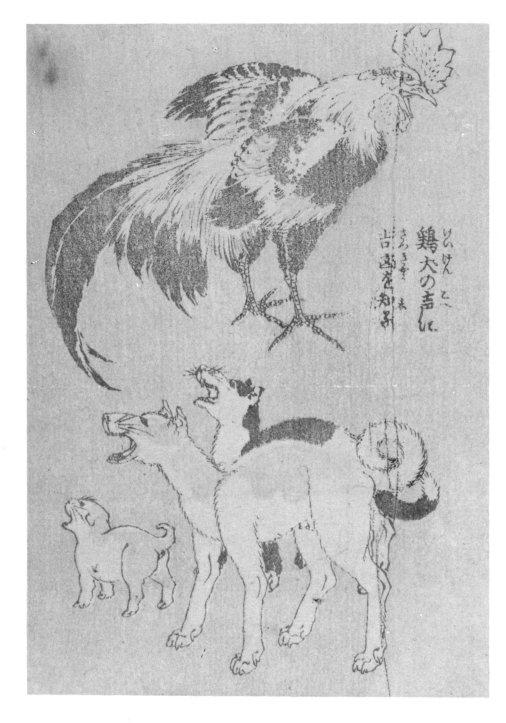

Japanese woodcut print HOKUSAI
More than naturalism animates these clever drawings of Hokusai. Their simplicity and design are immediately appealing.

"Somnolent Lion"　　　　　　　　　　　　　　　　　REMBRANDT

　　*Rembrandt drew this sleeping lion at a traveling zoo which stopped at
Amsterdam. It shows his preoccupation with the natural aspect of the animal.
He does not invest it with a false grandeur; he drew it as he saw it, without
dramatization.*

"A Bison"　　　　　　　　　　　　　　　　　　　　DURER

　　*By comparison, this drawing of Durer's seems stiff and informative
rather than spirited, though it too was drawn from life.*

115

see it as it is. I remember a drawing made by a small boy many years ago. He knew goats very well. He took care of them, raised them, and he loved to draw. One day he showed me some drawings of goats. They were extremely simplified, the body triangular, the head a small triangle. Sticklike legs supported the body but somehow his drawings understood the forms and gave me the authentic feeling of goats. I looked at the animals more closely and I found he was right to have seen the triangle of body and head.

Many years later I leafed through a book published in Holland and found some illustrations for Virgil by a modern and sophisticated artist. Here again the same abstract shapes were used to indicate the goat.

If you live in a large city, the zoo is exciting and interesting. Go to see the big cats. No more perfect animal mechanism exists. You can see the ripple of muscle under the thick shining fur. Observe how the cats carry hindquarters high and head low. Study the sinuous unbroken line from head to tip of tail.

Animals out of doors move about so that no more than a few lines can be drawn to indicate their movements. Keep drawing as the animal moves. Make new drawings, using the method described in *Articulate Movement,* of many lines, accenting the one that seems nearest to the correct form. Allow all of the lines to remain. Do not erase.

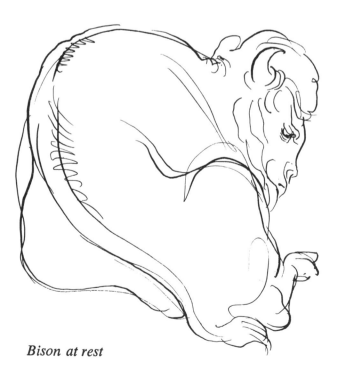

Bison at rest

116

II. TECHNIQUE IS THE MEANS

In the chapter on materials I briefly mentioned the fact that the tools to a large extent control technique. Even more important is the choice of a given tool.

It is well to remember that the best use of technique is one in which the mechanics, though present, are unobtrusive. Personal mannerism exists, of course, and has its place in drawing but in this book we are concerned mainly with mechanics of technique in their simpler forms: how actually to use the materials to the best advantage.

Technique or the *how* of drawing is not the most important phase of creativeness. Techniques should not be used as a bag of tricks to dazzle by skill in performing, but rather should serve a natural means to an end.

Some technical devices are helpful in producing form. Some develop line and some are combinations of both line and form.

Without too much emphasis on personal working style I want to point out in this section natural ways to achieve varied effects with the materials of the craft.

PEN AND INK AS A MEDIUM

The pen is a natural medium for drawing and has great versatility. It has long been a favorite tool in every phase of drawing and illustration. The fountain

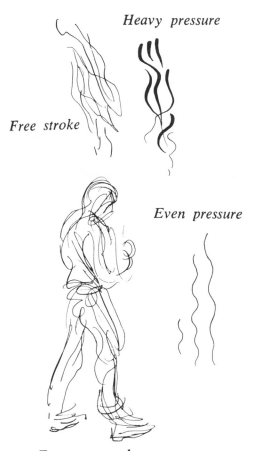

Heavy pressure

Free stroke

Even pressure

Free pen stroke

pen, especially made for drawing, must be kept in good condition. Be sure it is clean. Fill it with a good not-too-thick Indian ink. Indian ink is sold in bottles ready for use, but it will thicken if you leave it uncorked. It can be thinned with distilled water, however. The drawing fountain pen has no sac, simply an open barrel. The point is retractable and must be filled with an eye-dropper at the point end when the point is retracted.

Wipe it after use—retract the point, and put the cap in place. Be sure to leave it with the point end upright until it is used again. Unless it is fitted with a clip, do not carry it in your pocket.

All pens work better when clean but not new. I find that if you hold the pen farther away from the point than you would normally in writing, a freer, more flowing line results. Try the point for quality of line, learn what happens when pressure is applied, and what sort of line results from even pressure. All of the pens described in the materials chapter may be used in this way. A variation in style results from the choice of a fine or stiff point or a broader, more flexible one.

Paper plays a large part in pen technique. A smooth paper will allow a free-moving line, while a paper containing even the slightest texture will affect this freedom. The pen may be freely used in building form with many lines, accenting the outer edges of the form.

PROBLEM 19

Experiment with the stippling of dots on the paper.

PROBLEM 20

Experiment in line and tone with coloured inks on grey-toned paper.

These adventures with technical means will keep alive your interest, but don't expect them to create art by themselves. Some of the greatest drawings in the history of graphic art were made with a simple pen line in black ink on white paper.

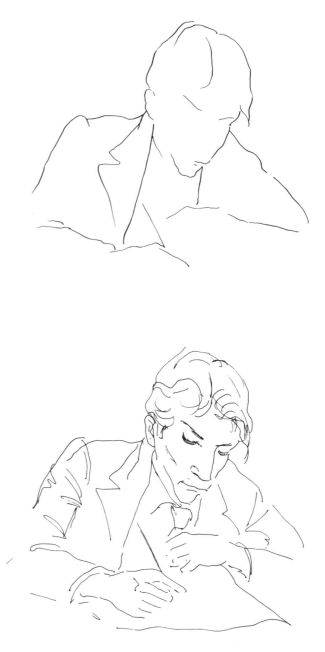

118

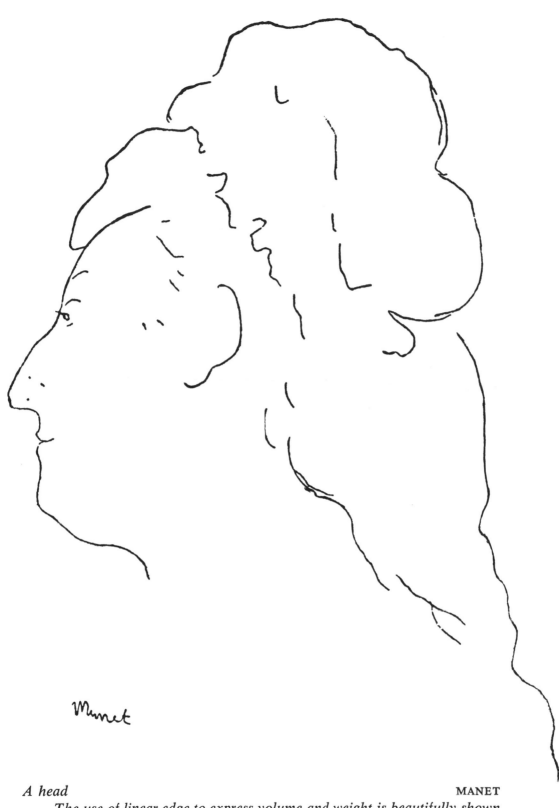

Munet

A head **MANET**

*The use of linear edge to express volume and weight is beautifully shown
by this drawing. Study the in and out quality of the line which is responsible,
despite extreme simplification, for the feeling of form.*

119

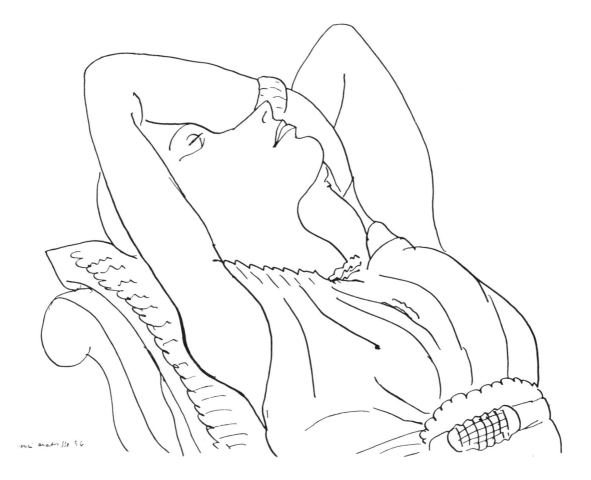

"*Girl Resting*" MATISSE
This drawing is in reality a complex of beautiful rhythmic lines.

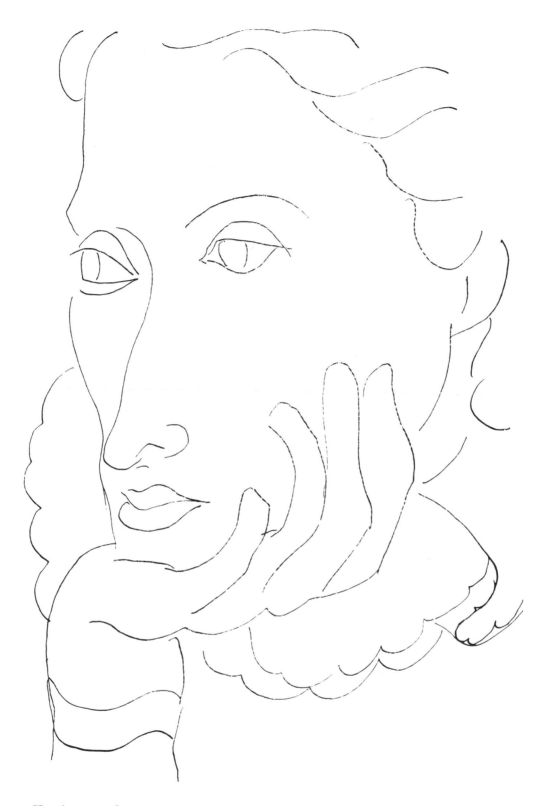

Head in pen line MATISSE
*This almost extravagantly simple drawing is composed completely of
curved rhythmic lines.*

A crowd TIEPOLO

 It would be hard to find a drawing in which the principle of simplifying to essentials is more clearly expressed than in this spirited sketch by Tiepolo.

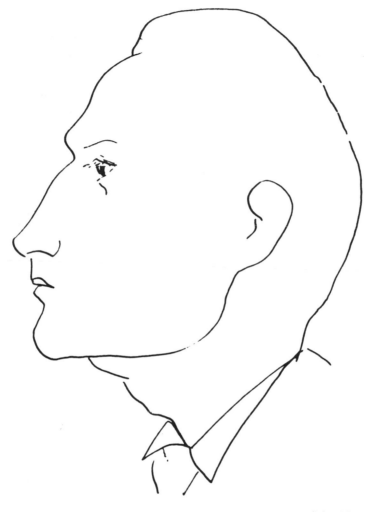

"Henry de Montherlant" MATISSE
This is a drawing reduced to its essence. Sometimes Matisse will first make a strongly modelled realistic statement and gradually, through a series of drawings, eliminate each unnecessary line.

WASH AND PEN AS A MEDIUM

This method is extremely interesting for those who would capture fleeting movement and whose bent runs to abstract devices. It will indicate rather than realize forms.

Wonderful examples of the use of this mixed technique of line and tone are to be found in the work of Rembrandt and the great Italian decorative painter, Tiepolo, who worked in the eighteenth century. In Tiepolo's drawings one sees an ideal use of the abstract device of two tones and sometimes one tone of wash, used over a rapid free linear drawing to enhance the feeling of form. There is no recourse to realistic lighting in these sketches, nor is there, for that matter, in most of the Rembrandt drawings. There is only a flat tone freely moving over the forms defining shadow areas and relieving light.

PROBLEM 21

Make a number of sketches with the pen and wash of figures in movement. Then, using a #4 watercolour sable brush, make a grey tone with lampblack and water in a palette or tray. Try it with the brush to see its depth of tone. Let your tone of grey dry because it is hard to judge the depth of damp colour wash. The stroke must be done with freedom and very quickly or it will defeat its purpose. Often I begin my own drawings with wash first and after the wash is dry draw with free pen lines.

In this case you are reversing the technique: the wash is used to indicate the characteristic movement rather than the form. Actually it performs both functions in the finished drawing, since the linear

pattern is developed on top of the wash with the pen. In this way the wash, together with the pen line, indicates form as well as movement.

Wash on damp paper

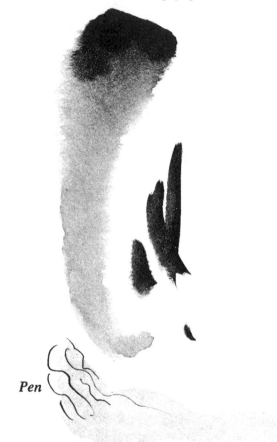

Pen

Tone on dry paper

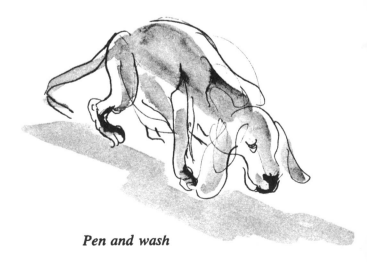

Pen and wash

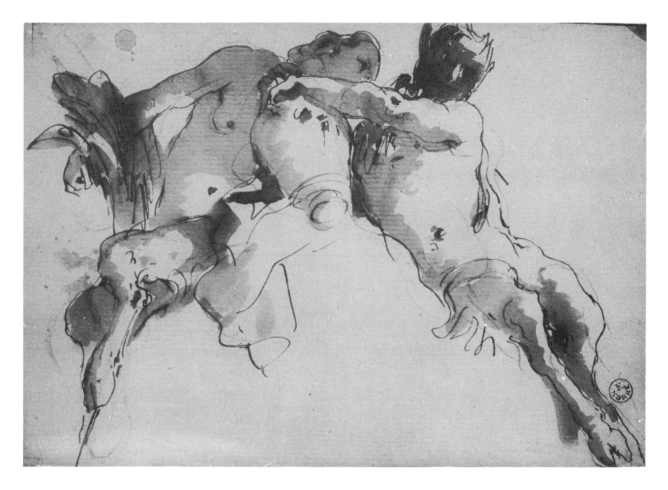

Note for a decoration **TIEPOLO**
*An arbitrary use of wash over a pen line suggests form with utmost
freedom in this brilliant drawing.*

CASEIN TEMPERA OR GOUACHE

The materials to use for casein tempera painting or drawing are: Casein white titanium, ivory black, burnt sienna.

The medium used for thinning is water.

The brushes are round oil oxhair, #3 and #6, and a flat #12.

You will require a tin or china palette made with wells to hold colour.

The base or surface may be charcoal paper or heavy cardboard. In the case of cardboard you will probably want to give it a coat of either thin casein glue or shellac. Either one will cut down the absorbency of the surface and so make drawing easier.

Casein tempera which is so much used in modern drawing and painting is one of the oldest techniques.

The great advantages of casein is its rapid and complete drying quality. In addition, it stays wet long enough to allow one to paint into the wet edges and so soften edges of the form if desired, or allow a gradation of tone values. It may also be used thin as a washlike medium or thick as in impasto oil technique. In its thin form it is usually referred to as gouache. Generally its quality is opaque but it may be thinned with water until transparency is reached in some spots. Once the casein sets, it may be painted over without the colour beneath bleeding through.

When you start you may find it easier to mix your three values of dark on the palette first. Squeeze some of the black into one well on the palette, then in the next well a little less black and add some white. In the third well, squeeze white first and add a little black. Then add black or white to your mixtures until the scale of values is clear. Dip your brush in water when you are working or the tempera will thicken and drawing will be difficult.

Casein colours may be kept soluble for a long time by adding a little water; if you wish to keep them overnight the palette should be covered with a wet cloth. Experiment with this material until you discover its possibilities for yourself.

The drying quality of casein and the simplicity of its preparation make it an ideal medium for out-of-door sketching.

You must wash your brushes with warmish water and soap while they are still wet. Once the colours are dry they are insoluble. Be careful not to use too hot water. It will harm the brushes.

THE USE OF OIL COLOUR

This approach is *not* to be considered painting. The surface is not important. The end is not slickness or smoothness in these studies. They should be thought of as form drawings. No attempt should be made to indicate the local colour with the colours at your disposal on the palette. Save them for the more important function of form. Try for plastic representation. Lay out the palette in this order:

The colours are: titanium white
 burnt sienna
 viridian
 black.

You must have an oil cup, a palette, turpentine to thin the paint, a #6 round bristle brush, two #8 flat bristle brushes.

Use a large sheet of masonite 20 x 30. If you are bold, use 30 x 40. Coat it with flat white as described in the materials chapter. Dip a rag in turpentine and burnt sienna and rub it over the whole surface of the board until it is covered with an uneven reddish coat.

Then with a clean dry bit of rag, pull out the areas of your drawing that will suggest the characteristic movement as you did earlier with a kneaded eraser on charcoal or crayon drawings.

Now let it dry a bit. It will set very quickly.

Mix some black with the sienna and begin with the round brush to search for the linear edge of the forms, beginning as before with the long lines and then opposing lines. After the linear edge is drawn, consideration should be given to the form.

Model with the darks at the outer edges of the form, then the transition, then the light. It will not look like the lighting on the model, but it will give a much more solid sense of form and will point the way to simplification, which is so important in finally creating worthwhile values in drawing.

Use black and sienna to indicate the deep shadowed portion of the form. Feel the roundness of the form. Darken the outside edges. Mix white and green to a value somewhere beween the light of the ground colour and the dark of the shadow.

Use this as a transition from the dark to the light. Oil is a good medium for long study because it can be used either transparently or opaquely, thinly or thickly, and with it you can build a sense of form. Experiment with it. Try the oil in one colour with white alone, as you did with three. Try building up the light areas very thickly and the shadowed areas almost transparently thin. Finally, paint in the light areas with a value mixed from white and sienna. Stay away from the high lights and cast shadows in this experiment.

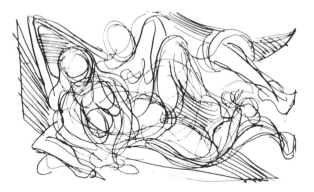

12. EXPLORING NEW ART FORMS

New frontiers are being extended in art. Abstraction, non-objectivism, cubism, surrealism, and expressionism are in common use. The beginner is concerned with new ideas in art as much as with its long history. Many of the ideas expressed in this book owe much to expressionism and some to abstraction. A short definition of a few current terms may help to clarify each.

ABSTRACTION

Abstract qualities exist in every work of art. Contemporary abstract painting and drawing is devoted to these values alone: form and shapes suggested by nature but rearranged and placed so that their harmonies and rhythms emerge. Objects and forms and shapes are broken up in this art form into their component lines, which are then separated and placed in the composition according to the judgment of the artist.

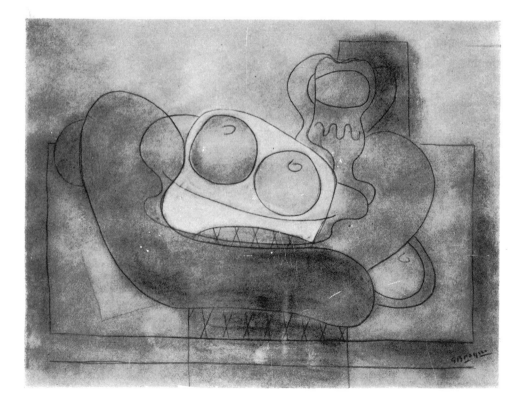

Drawing for "Les Grosses Pommes" BRAQUE

128

CUBISM

Cubism is not only the attempt by means of abstraction to flatten out and geometrize and regroup objects in nature. It even attempts at times to show the back planes simultaneously with the front ones. So it makes use of transparency. The intersections between planes is emphasized. Sheldon Cheney in describing cubism's fundamental idea says: "It is possible to disassociate the planes of an object seen and to rearrange them in a picture so organized that they will give a truer emotional or structural sense than the original appearance."

"The Table" BRAQUE

129

Figure GRIS

"Portrait of Karl Kraus"

KOKOSCHKA

EXPRESSIONISM

Expressionism searches with intensity for form and structure. It makes use of violent distortion to express emotion felt by the artist at a creative moment. Unlike cubism with its rules and planned sequences, expressionism is the medium of the individualist. The expressionist makes use of nature as subject matter, and expressionism is concerned with describing the emotional response of the artist to a scene or person, an object or still life. Many of the expressionists radically simplify the pictorial elements of their compositions.

131

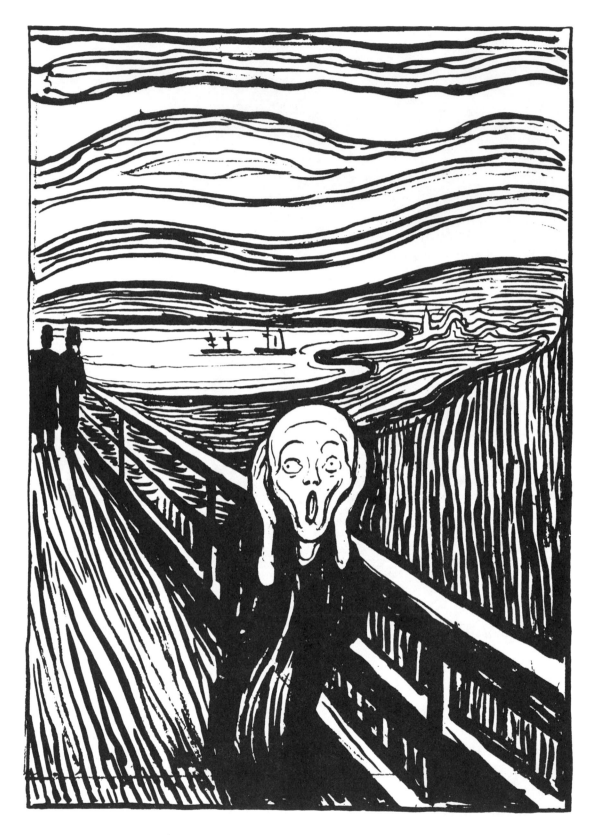

"The Cry," a lithograph MUNCH
 An early example (1895) of expressionist drawing, which makes us feel
the impact of sound and terror, by the Norwegian painter, Edvard Munch.

132

"Hunger"
 Expressionistic drawing

KOLLWITZ

NON-OBJECTIVISM

Non-objective art had its roots in Germany in the first decade of this century. The material of a non-objective composition is based on geometric and non-geometric shapes and what are referred to as "free" forms, unlike forms in nature and unlike recognizable objects. The artist would give these shapes and lines life of their own, divorced from any resemblance to objects we see and know. Invention, of course, plays a large part in these designs. Colour, values of dark, textures—are all employed in non-objective drawing. The terminology is peculiar to abstraction, as, for instance, the use of the words "tensions," "rhythms," "space," to describe particular expressions of non-objective design.

"Mythologie de la Nature" MASSON

SURREALISM

Surrealism is art symbolism in terms of Freudian interpretation. Its terminology is modern but the technique in drawing of one of its major figures, Salvador Dali, resembles the work of the Italian Renaissance much more than it does that of his contemporaries. When we describe surrealism we use literary rather than art terms. The subject is important, and as if to emphasize this, the techniques are realistic and polished. Juxtaposition of apparently unrelated objects makes stronger its dream—perhaps nightmare—effect.

134

13. SUMMATION

The point of view of this book is bound to be one that is personal. It is the expression of my feeling about the creative process in drawing and so concerns the artist as well as his work.

The examples of drawings in this book and their brief analyses are likewise personal choices and personal interpretations. There is no doubt that so long as pictures are made, they will allow of infinite interpretation and explanation and analysis. Each artist has his own view of what surrounds him and what is within him. His expression is his contribution to the broad stream of art. And just as the practice of the graphic arts goes back into the dim and even prehistoric past, as we have seen, so will it continue.

The illustrations from the masters which are part of this book are meant to serve two purposes:

First, they are intended to illustrate certain phases of drawing techniques, which can best be understood by seeing these techniques at their very highest expression.

Second, the reproductions should lead you to the museums in which you can see and enjoy the originals of many more of the old and modern masters. Drawings, lithographs, etchings, and woodcuts are more readily available throughout the country for study and for enjoyment than are paintings.

As for the problems, they are keys to learning. You must invent other problems for yourself and continue to draw. Many people go to art classes because they feel that unless they have a definite schedule of work, they will not stick to it long enough to learn. There is a great deal of sense in this. To learn to draw from a book or plan requires that you draw at every opportunity. You must draw from nature. You must draw from imagination. And you must experiment with the tools of drawing.

As you have followed my book in your desire to learn to draw, it is my hope that it has awakened a lively interest in you to draw for the sake of self-expression. It is also my hope that you will take from this book what is of most value to you. It may, for example, cause you to re-examine your own attitude toward drawing and to adopt a broader approach. But its first intention is to offer a basis for self-criticism and for understanding art. The terms defined are meant to be helpful but my book is essentially a framework and does not go beyond the simplest of art criticism. It is sincerely meant as a starting point.

INDEX